Ethnic Sculpture

**MALCOLM McLEOD
AND JOHN MACK**

Published for
the Trustees of the British Museum by
BRITISH MUSEUM PUBLICATIONS

BMP

**THE TRUSTEES OF THE
BRITISH MUSEUM
acknowledge with
gratitude the
generosity of
THE HENRY MOORE
FOUNDATION
for the grant which
made possible the
publication of this
book.**

Front cover. Head of a figure
of a deity, Austral Islands.
Features of the face and body
are indicated by small figures,
possibly suggesting the role of
the god as creator.

Inside front cover. Many
cultures carve, model or cast
smoking pipes in the forms of
other objects, or people and
animals, often making visual
jokes by identifying parts of
the pipe with the parts of the
body being depicted. This
pipe bowl comes from the
Northwest Coast of America.
H. 10.8 cm.

Title page. A range of objects
may receive sculptural
elaboration beyond their
functional needs. This is part
of a *gamelan* orchestra from
Indonesia. Many of the
instruments are supported by
images of mythological beasts.
H. (entire) 187 cm.

Right. Pottery vessel, Moche,
Peru, late 6th – early 8th
centuries. The individuality of
some Moche pottery has led
to suggestions that portraiture
was a part of this tradition.
Heads and full figures are
known with modelled and
painted features, some
attaining a realism consistent
with their having been created
from life. However, as the
tradition is known only from
archaeological discoveries,
there can be no direct or
ethnographic confirmation of
this. H. 24 cm.

Far right. Wood 'portrait'
mask, Kwakiutl, Northwest
Coast of America. This
particular example, although
of mid-nineteenth century
manufacture, shows no signs
of having been used and may
have been made specifically
for sale. H. 23.5 cm.

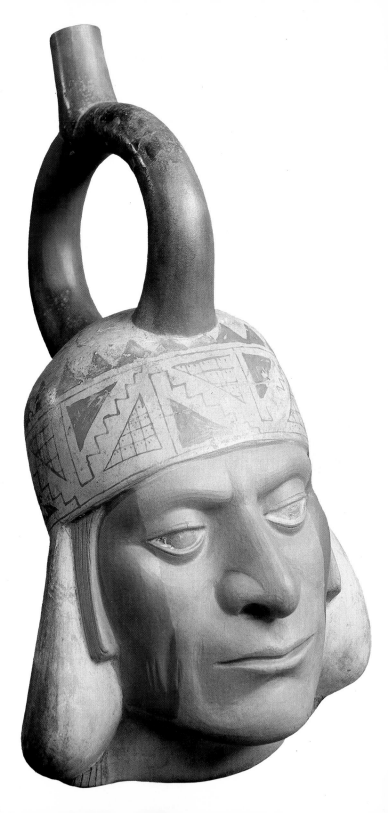

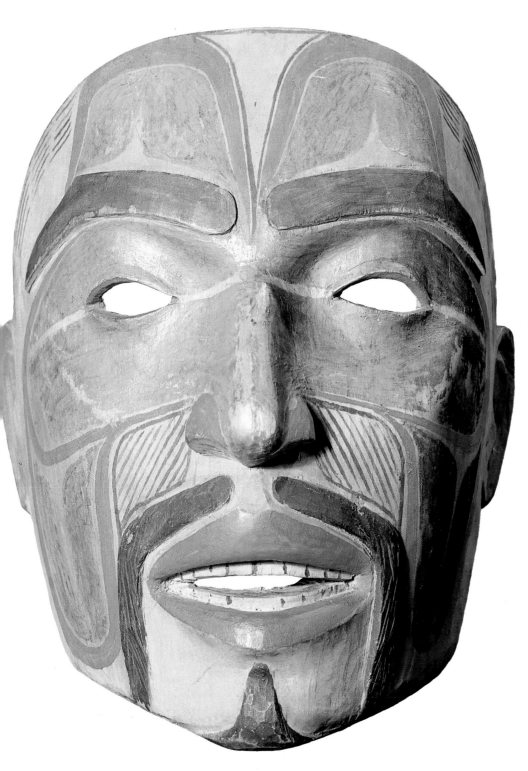

Contents

Preface

A number of illustrated catalogues of the rich collections of the British Museum's Deartment of Ethnography at the Museum of Mankind have already been published. The original guide, *The Handbook to The Ethnographical Collections*, appeared in two editions (1910, 1925), and a shorter updated version is included in the *British Museum and its Collections* (1982). William Fagg's *Tribal Images* (1977) discusses individual sculptures from various parts of the world in more detail, and specific parts or areas of the collections have been the subject of separate treatment. Here rather than giving collection details or concentrating on individual works, we have tried to provide an introduction to some of the themes and perspectives evident in the artistic traditions of the non-Western world. Where relevant we have contrasted these with developments in the European tradition to provide the general reader with an accessible point of reference.

We have not therefore specifically sought to reflect the breadth of the British Museum holdings but have rather selected examples to illustrate particular points. Archaeological cultures, for instance, or the classical traditions of pre-Hispanic America are touched on only briefly. Nevertheless, we have made the discussion as broadly based as possible and use illustrations from a wide variety of geographical areas and from different types of society. The Museum's Photographic Service and in particular Henry Brewer have provided the bulk of the photographs.

In addition K. Poku, M. O'Hanlon, Dr J. Brown and Dr J. Bloss have supplied photographs, for which we are grateful. We also wish to acknowledge that parts of our discussion of the differences between Pacific and African sculpture derive directly from Dr William Rubin's introductory essay in the catalogue for the exhibition *'Primitivism' in Twentieth Century Art* held at the Museum of Modern Art, New York (September 1984 – January 1985).

1 Introduction

This is a book about sculpture. It is not, however, mainly concerned with portraits, commemorative images, monuments to the great or other of the usual categories within which Classical and Western traditions tend to place three-dimensional art. Indeed, it is nor necessarily a book about 'art' in any restricted or conventional sense. Instead our intention is to provide a short introduction to the sculpture of the non-Western world from an anthropological and technical point of view rather than, as so many surveys do, to concentrate on aesthetic commentary. We believe that in dealing with sculpture from other societies it is more illuminating to discuss how it is made and used than to impose upon it ideas about its form or qualities which its makers and users would not necessarily recognise or which, for a variety of reasons, must be entirely speculative.

Our emphasis is therefore largely on the contextual and not on the more directly formal aspects of the objects and traditions discussed. We will consider the social and ritual background to particular images, discuss how they are used, and examine their connection with other visual, as well as verbal, modes of expression. For specific objects and traditions these themes will be pursued in captions accompanying selected illustrations. The main body of the text will highlight some of the principal points which emerge from this perspective and indicate where they diverge from our commoner assumptions about sculpture.

At the outset it is worth stressing that there is nothing unique or innovative in our general objectives. Indeed, no definitive line can easily be drawn between the aims of art history and social anthropology; put simply, both start from the idea that the enjoyment of an image might be supplemented and deepened by locating it in its broader cultural situation and seeking an understanding in this area. The evidence to which each must turn, however, is certainly different. For one thing, the societies whose visual images are surveyed here are largely pre-literate, and there are no internal documentary records on which to draw. In many cases we know neither the names of the artists whose creations we examine nor do we have details of their personal experience to which we may refer. Moreover, as most of the images which concern us are single figures rather than tableaux, they do not, of themselves, have an easily grasped story to tell: in fact, many are not visual narratives or commentaries in this sense. In their interpretation, therefore, historical evidence is necessarily replaced by anthropological, by the direct observation of the societies which make and use particular objects. Nevertheless, art historians and social anthropologists seek to explore the same territory, and the ways in which they work and build up their interpretations are closely similar.

There is, however, one important difference between the two. Social anthropology

The sculptural elaboration of everyday objects occurs among many peoples. This gaming board from the Yoruba of Nigeria shows something of the richness of the Yoruba tradition of carving. L. 48 cm.

Pair of wooden doors, Yoruba, Nigeria, with high-relief carving showing a series of everyday and historical incidents. The scenes do not interrelate to show a sequence of events but rather illustrate sculpturally a number of independent events. Such pictographic carving is familiar in the Yoruba tradition but relatively uncommon elsewhere where single figures predominate. H. 213 cm.

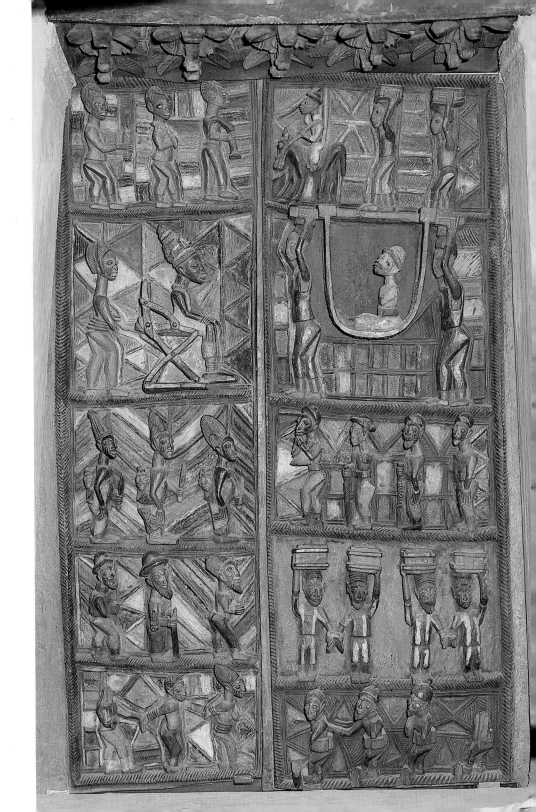

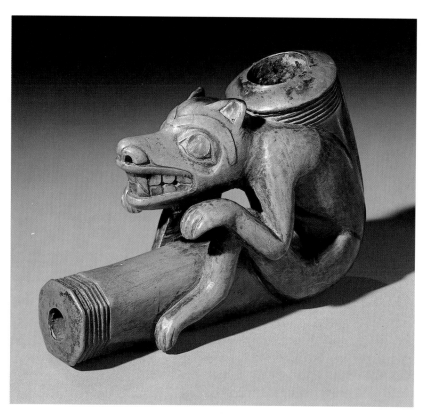

Many cultures carve, model or cast smoking pipes in the forms of other objects, or people and animals, often making visual jokes by identifying parts of the pipe with the parts of the body of the being depicted. This pipe bowl comes from the Northwest Coast of America. H. 10.8 cm.

and art history are clearly products of the same intellectual traditions. Art history, though, has developed its expertise, its assumptions and its vocabulary in the treatment and interpretation of materials that come from this tradition. Its development is intermingled with that of the arts on which it comments, and minor adjustments are readily introduced into its terminology to accommodate further subtleties and nuances as they arise. Social anthropology, by contrast, lives in several worlds at once, for it is engaged in the business of translating unfamiliar ways of life into language and idiom that render them more accessible. To do so considerable care must be exercised in its choice of vocabulary. A common and apparently useful term such as 'religion' calls to mind a whole range of ideas based on predominantly Western and Christian experience which may hinder rather than aid the handling of complex varieties of cultural practice.

It may be difficult to appreciate at first that a word such as 'sculpture' might be prey to the same difficulties. After all, a mask from a non-Western culture when placed in a museum or hung, carefully illuminated in someone's house, is approachable in terms little different from any other object similarly displayed. It appears cosmopolitan, and it is easy to forget that it was never made to be seen in this way. In its original cultural context it would be viewed in movement, together with a costume, possibly to the accompaniment of music, singing and noise, and in the course of some ceremonial performance which imposes yet other expectations and criteria of assessment. We shall return later (Chapter 4) to examine the variety of these attitudes to masking.

In contrast to the European tradition almost all the sculpture discussed here was not made to be seen either in isolation or even in any one specific or predetermined kind of place. Masking is far from being alone in this. Unless intended as some directly architectural feature, a house post or door, for example, the surroundings in which the object is to be viewed are not generally a consideration in its construction. Much non-Western sculpture has a strongly functional character — another major divergence from our usual expectations of such images — and it is therefore moved about as required, often being brought into public view only when it is in use. At other times it may simply be stored more or less out of sight. In these circumstances the assumption that such

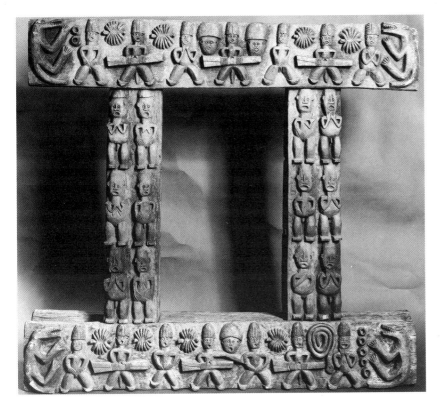

Wood door frame for a Bamileke palace, Cameroons. Much of the sculpture incorporated into architectural forms is carved or modelled in relief and can be viewed from the front only. House posts including figurative images are, by contrast, usually carved in the round; but even here those posts facing outwards towards the daylight may be more easily seen than the darker surface facing inwards. This too may be a factor in their construction. H. 200 cm.

sculpture occupies, and was made to occupy, a particular space, is misconstrued. Indeed, it may be that the physical presence of the sculpture may serve to create or define a particular space around it rather than the reverse, which, if pop art and other modern developments in Western art are to be believed, is a limiting assumption embedded in European ideas.

In endorsing the term 'sculpture' in the title of this book, therefore, no restrictive definition is intended. Instead, it is used in a largely technical sense: to describe a three-dimensional object, usually, though not invariably, a manufactured one, one which has been carved or cast, modelled or assembled from a variety of materials. Additionally it will usually refer to, repre-

sent or act as a replacement for something beyond itself. If it is also pleasing to the Western eye, then that is a bonus, but that is not a criterion for discussing it here.

In giving the term 'sculpture' a wider sense than it usually has in the West it is easier to map out indigenous points of reference in describing traditions which have emerged beyond the horizons of European culture. This introduces a range of cultural attitudes which are often at variance with Western expectations and frequently at odds with each other. The spectrum of such attitudes runs from apparent indifference to sculpture to clearly conceptualised aesthetic preferences expressed in a vocabulary which may be more detailed and precise than anything found in European languages.

These varying attitudes to sculpture can be demonstrated by a few examples. For instance, the Kalabari Ijo of the Niger Delta make, amongst other figurative sculpture, a variety of masks. These are used in performances associated with placating unpredictable water-spirits which might interfere with the success of fishing expeditions. Kalabari themselves seem to regard these masks with apathy: they are necessary, certainly, to diminish the hazards of a dangerous, if prestigious, occupation, but beyond that they are unregarded. When not in use, the masks are never placed in positions convenient or suitable for viewing them, and outside the performance in which they appear they hold no particular mystique. The carvers charged with making masks are by no means skilled craftsmen with a proven and practised talent in this field; in fact, they usually turn out to be men who are too old or ineffectual to engage in the much more fitting business of fishing. The creation of objects that conform to any abstract notions of form or

beauty is not part of the Kalabari tradition, but their sculpture should not be excluded on these grounds from discussion.

Much effort has been expended in an attempt to prove that sculptural traditions such as that of the Kalabari Ijo are atypical. It has been argued, for instance, that it is naive to believe a society must have a word for 'art' before it can have 'art'. Aesthetic judgement can be exercised without the presence of a technical vocabulary. Whatever the merits of such arguments, it is striking that the most convincing evidence of the deployment of distinctive aesthetic criteria outside western culture is often found in areas where it might be least expected.

Amongst many pastoralist peoples in East Africa, for example, what are clearly aesthetic criteria are applied not to figurative images, which are in any case very rare in that area, but to cattle. This is best documented for the Nilotic peoples of the Southern Sudan. Here milk yield, which by external standards might seem the crucial factor, is only one of several considerations used in judging the quality of a good herd. Cattle are bred to try and produce specific colours or particular configurations of colour with different regions or clans having their own preferences.

When boys in these societies are at an early age they are given a bull whose welfare becomes one of their main preoccupations. The young warrior composes songs to it, shares its name (in some places if his bull fights with someone else's, it may be a reason for the owners themselves to fight), and if it dies, he may commit suicide. The bull is also the subject of close aesthetic attention. It will be decorated, and whilst young its horns may be chipped and tied together so they develop into juxtaposed arcs: again there are established preferences in the final form the 'sculpted' horns should achieve. Clay models are frequently made giving form to the ideals and, in dance, the horn shapes are reproduced by gesturing with raised arms.

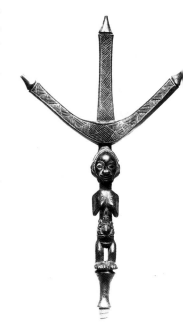

Clearly cattle as such are not artefacts; yet when they are the focus of such close aesthetic and social attention, neither are they simply cattle. As the subjects of pride and boasting, of lengthy and detailed discussion of form and colour conducted in a specialised vocabulary, and as the models of aesthetic ideals (and, up to a point, of moral ones too), they engage and even surpass most of the criteria conventionally applied in the West to sculpture.

Cattle also break the bounds of our commoner expectations of sculptural traditions in another way: they move. This fact is exploited by the widespread practice of hanging tassels to the tips of their horns so that they swing when set in motion, further enhancing their visual qualities. Cattle, therefore, like maskers, actively intrude into space occupied by the viewer, a comparatively rare phenomenon in the Western tradition and one which remains so despite the experiments with mobile sculpture in the present century.

From the Western point of view such indigenous attitudes to cattle seem, perhaps, to overvalue what we might otherwise term 'sculpture', just as the prevailing opinion amongst the Kalabari appears to undervalue it. Certainly we are dealing with two extremes, and between lie a range of attitudes some more closely in accord with expectations based in Western cultural experience. These two examples, however, serve as a reminder that familiar categories of thought and assumption are not necessarily transferable to traditions that have to a large extent developed independently of European influence.

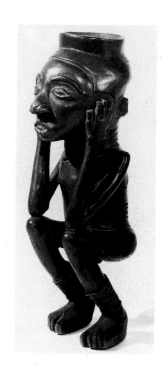

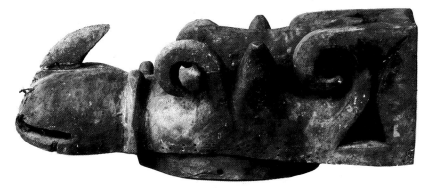

The dance masks of the Ijo of the lower Niger are worn on the top of the head, show wide variety of form, but arouse little asthetic interest among local people. L. 73.7 cm.

Opposite (top). Wood bow stand, Luba, Zaire. The presence of the carefully carved female figure indicates that it was intended for use by persons of high rank, but it is otherwise a functional object. As used it would be stuck in the ground, the bow resting on the two front projections. H. 68 cm.

Opposite (bottom). Wood cup for drinking palm wine, Kuba, Zaire. Many functional objects are treated as sculptural challenges in an artistic tradition notable for its plays on form and design. The existence amongst the Kuba of an elaborate court system has encouraged such an innovative approach. H. 26 cm.

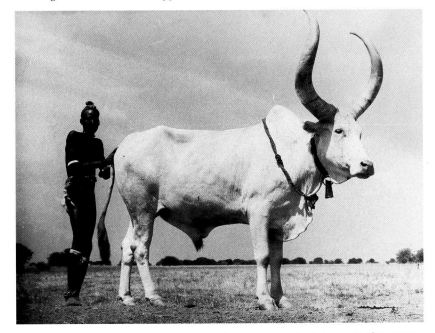

Among the cattle-keeping peoples of the southern Sudan aesthetic interests often centre upon the colours and forms of particular animals whose horns are trained into desired shapes.

The 'discovery' of non-Western art

Examples of exotic sculpture have been collected and brought back to Europe ever since the days of the earliest voyages of exploration. At times such works were certainly admired as evidence of indigenous craftsmanship – particularly those objects with a more obviously utilitarian function, such as carved spoons or combs. In a few cases this induced European visitors to commission objects after their own prototypes; more characteristically, however, these collections tended to be taken as evidence of the backwardness of their users, as trophies of a primitiveness lying beyond the peripheries of European civilisation. Figurative sculpture, once associated with ill-understood ritual practice, quickly became a token of all manner of apparently misguided religious belief. Thus by the beginnings of the present century many thousands of examples of non-Western sculpture were already in public and private collections in Europe; yet, whilst a few of these images had begun to provide novel motifs and forms for the occasional artist or designer, interest in them was for the most part confined to anthropologists and scientists. It was only when the geographical expansion of Europe overseas had reached its maximum extent that this interest became more general.

It is now widely accepted that African and, to a lesser extent, Pacific sculpture was discovered by artists working in Paris in the first decade of this century and, in particular, by Picasso and his associates of 1906 – 7. In 1906 a Fang mask from Gabon was bought by Derain, seen by Matisse, Picasso and other artists, and was even cast in bronze by the art dealer Vollard. This mask led to the acquisition of other African

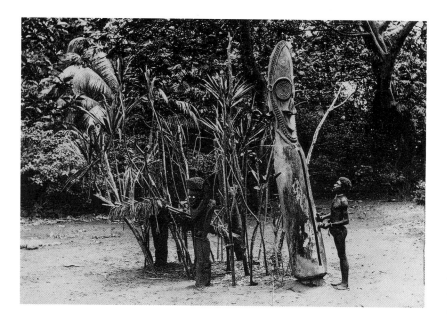

Wooden slit gongs of this sort were erected around cleared ceremonial centres in the New Hebrides and sounded on ritual occasions connected with the hierarchy of grades into which men were organised.

Wood food bowl, Solomon Islands. The bowl has been conceived as a bird with schematised head representing the frigate-bird and ending with the image of a fish. L. 51.4 cm.

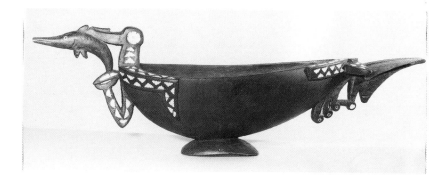

Opposite. European contact often led to changes in indigenous sculpture. On the Northwest Coast of North America many argillite carvings not only depict Europeans and their goods, often with humour, but were intended for sale to white visitors. H. 24.5 cm.

pieces by artists in this group and by the influential critic Apollinaire. It has been suggested that such African works were a crucial influence on the development of cubism and, in particular, that they inspired some of the forms of Picasso's great painting of 1907, Les Demoiselles d'Avignon.

A closer examination of the evidence, however, suggests that these blunt facts over-simplify what actually happened. Rather than African and Pacific art initiating or directing the development of cubism and subsequent non-naturalistic forms of art, it seems rather that they proved a resource of ideas for a movement which was already underway. As European painters explored new forms of representation, they found in exotic traditions alternative approaches which they could exploit. The interaction between the two traditions was not one of direct causality. Nevertheless, it is undeniable that without the revolution in European art wrought in the first decade of this century few of us would now be so willing to see virtues in alien traditions of sculpture which depend so heavily on a conceptualisation of natural forms rather than a direct imitation of them.

During, or shortly after, this period of so-called 'discovery' in Paris, the artists of the *die Brücke* and, later *Blaue Reiter* groups in Germany also took a keen interest in African and Oceanic masks and carvings. Once again they were not disappointed: they found what they were already looking for — an alternative tradition separate from, and independent of, what they believed to be the stultifying weight of the European artistic past. Like the cubists they were attracted by the non-naturalistic elements in such works, considering these to derive from an instinctive creativity, one untrammelled by

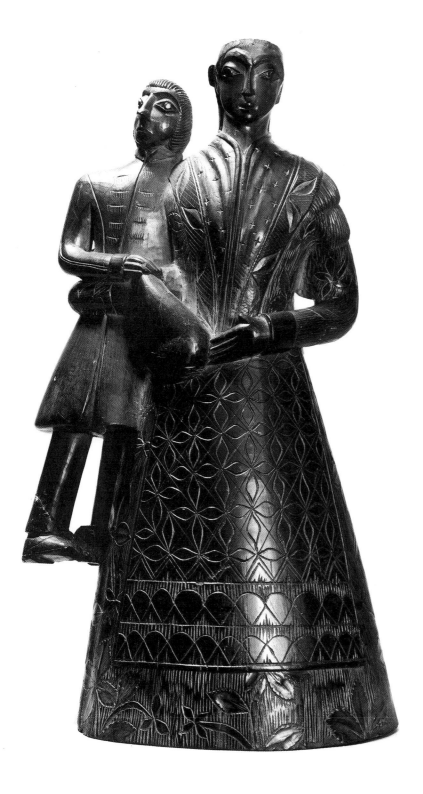

convention and traditions.

By the outbreak of the First World War African and Pacific carvings and European *avant-garde* paintings and sculpture were being exhibited together and about this time some dealers began to sell both sorts of material. In the 1920s articles on both traditions appeared together in advanced journals. What was first called 'art négre' ('Negro art') was partly absorbed into European experience and emerged as 'primitive art'.

Today we cannot discount a general familiarity with the cubist and subsequent European schools in assessing the esteem in which many non-Western visual arts are now held; and certainly the readiness to use terms like 'art' in these contexts is as much a mark of approval as an attempt at objective description. Such admiration, however, if not informed by a more detailed awareness of the original significance of such objects, leads inevitably to misapprehensions. That the carving traditions of Africa and other parts of the Third World are in essence conservative and their styles remarkably consistent through time is so much of a cliché amongst those professionally interested that many are disposed to doubt it can be entirely so. Yet at the same time an impression of the spontaneity and precocity of such works persists, perhaps the result of confusing the character of these traditions with the vitality and freedom claimed in the present century by Western artists. The practice of grafting on terms like 'cubist' or 'expressionist' to otherwise neutral descriptions of forms merely endorses the tendency.

Equally unfortunate are the many cases where images have been stripped of their original encrustations, and even clothing, applied by their makers and users, in order to disclose the significant thing about them

from the Western point of view – their underlying forms. Items of diverse characters and functions have, in this way, been reduced to a common category of 'sculpture'. It was difficult to avoid this approach: the western enthusiast was often confronted with the object but given little or no additional information because such sculpture had been removed from its place of origin without any attempt to discover its indigenous significance.

The study of this sculpture remains a difficult task. It is now impossible in some instances to form well-based conclusions quite simply because the cultures from which particular objects derive have now vanished. Moreover, even when knowledgeable informants are available, the difficulties for outsiders are considerable. In order to inquire into such meanings it is necessary for the outsider to be able to speak the local language with a considerable degree of fluency and be capable of identifying and understanding the implications of any metaphorical or analogical statements which may be offered in explanation. Some enquiries by outsiders may be positively unwelcome or resisted or answered with an evasive response, for the sculpture in question may be for use in an esoteric ritual whose secrets are closely guarded. Nor can it be assumed that all the members of a small-scale society possess knowledge more or less equally, or even possess the same sorts of knowledge about particular images: the creation and use of sculpture may, for example, be restricted to one group whose views of its significance may be different from those of the generality.

Equally, within a single society, there may be different types of sculpture which form parts of different systems of meaning and communication, each of which needs to be elucidated separately. Among the Kwoma of Papua New Guinea, for example, certain wood-carvings are placed in public areas where everyone can see them. Local people will explain without hesitation that the beings depicted in these are protagonists in their myths and legends. At least on a superficial level the 'meaning' of this sculpture is easily expounded because it is common knowledge within the society. Among the same people, however, there are other sculptures which are placed in the privacy of the building used exclusively by men, and kept tantalisingly just out of sight of the women of the village who are supposed to know virtually nothing of them. Enquiries among initiated men show that it is more difficult or obtain an indigenous explanation of the significance of these carvings. Although they clearly have great importance, there seems to be no way in which their meaning can be succinctly expressed in words. Any attempt by an outsider to understand them therefore requires a study of many aspects of the society's structure and symbolism, and ultimately a series of assumptions which might not be readily comprehensible to the members of the society itself.

Ivory salt-cellars, the one at the front carved by Benin craftsmen, Nigeria, that at the back by Sherbo carvers, Sierra Leone. Both were made at the behest of, and possibly after models provided by, Portuguese travellers. They were intended for use in the royal courts of Europe. H. 30 and 24 cm.

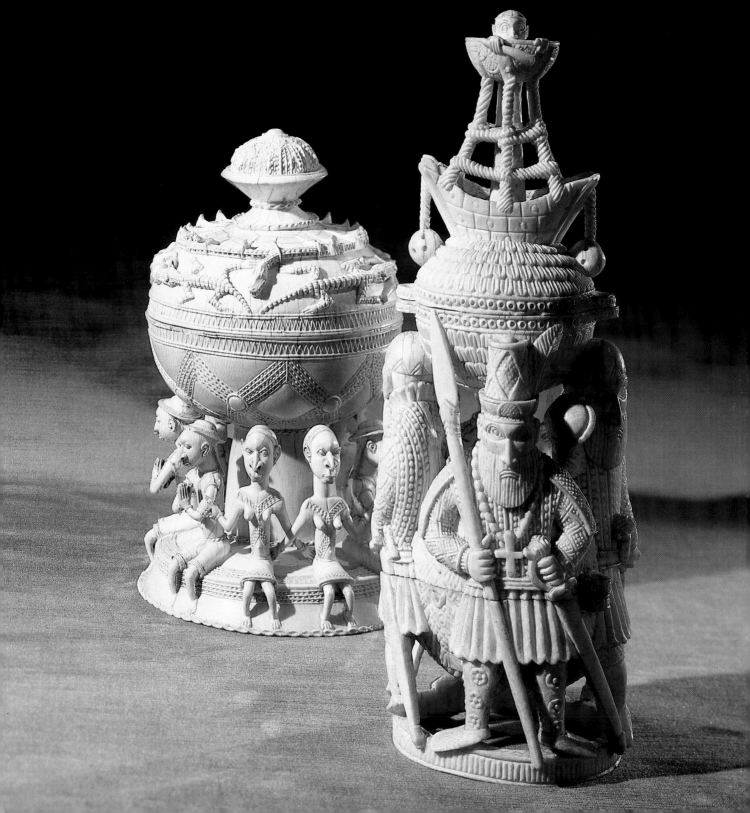

2 Techniques of sculpting

One of the more prominent features of the development of Western interest in ethnic sculpture is that it has been painters as well as sculptors who have been at the forefront of its elevation in public esteem. This no doubt reflects the dominance of painting in the Western tradition, at least since Renaissance times. The sculptural techniques in the non-Western world are, however, of interest and in some ways contrast with those of the European tradition.

In all societies one limitation on what can be created is the tools, materials and techniques available. In terms of materials the range of things considered suitable to be made into sculpture may frequently be far greater elsewhere than it has often been in the Western tradition. Thus a sculptor may use wood, clay, animal hide, vegetable gum, hair, human bones, even green leaves and other substances in his work, separately or in combination. However, in terms of tools and techniques the limits within which he works may be far narrower, for the societies considered here rarely have any source of power apart from the human body itself. All work, therefore, has to be

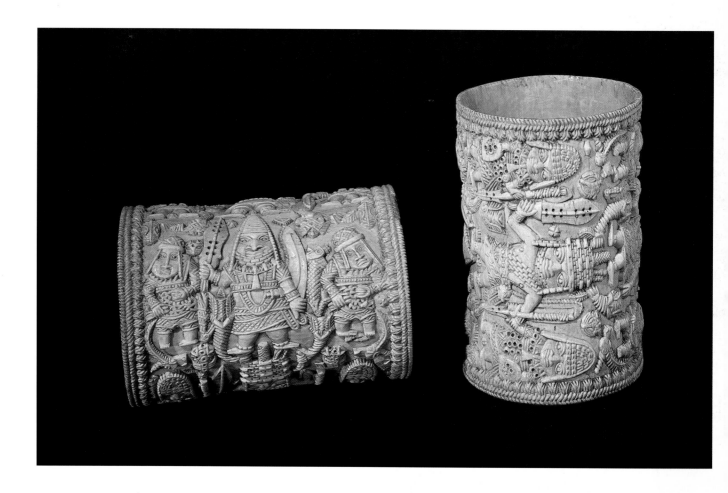

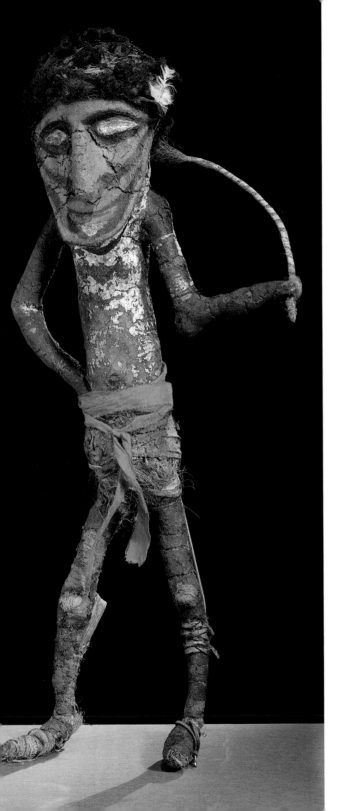

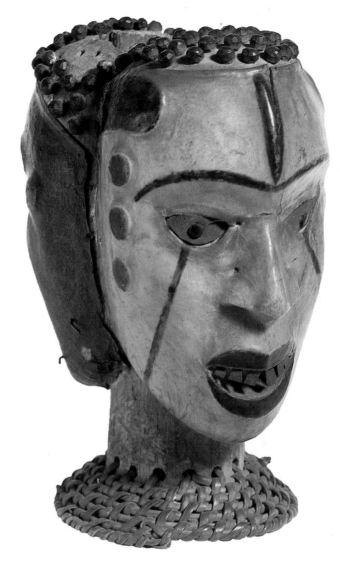

Above. Janus cap mask worn on the top of the head, Ejagham, Nigeria. A wood form has been covered with animal skin – this, the lighter-coloured side, representing a female face, the other darker side being male. H. 48.3 cm.

Left. Figure from Ambrym, New Hebrides, made of clay plastered over a vegetable fibre base. Like many objects collected late in the 19th century, little is known about the function of such figures, but it is thought they were displayed at festivals and may have represented ancestors. H. 58.4 cm.

Far left. Elaborate sculpture in hard or rare materials (stone, metal, ivory) was comparatively rare in Africa. These elaborate cuffs in ivory were produced by specialist craftsmen working for the court of Benin in Nigeria. H. 14 cm.

Wood chair covered with traditional motifs but after the fashion of European furniture, Chokwe, Angola. Its exotic form has led to techniques of carpentry being used in its construction rather than, as is more common, all carving being done from the solid. H. 50.8 cm.

Eskimo mask representing a spirit. The mask is so constructed, from small pieces of wood, that when its wearer dances the various parts move in different ways to give the impression that a multiplicity of beings or forms is present. H. 29.5 cm.

carried out without the help of machinery and engines; virtually everything is done by direct human exertion. While raw materials may abound, the sheer amount of human energy which can be diverted to work them may severely limit what can be created. This limitation also helps determine the value which is placed by society upon the thing produced.

Wood-carving

Most of the images discussed here are made entirely or mainly of wood, and most are shaped by cutting away at a single block, reducing it until the desired form is achieved. Carpentry, the joining together of separately carved parts, is relatively rare. The types of timber used vary greatly from area to area. In some cases the sculptor has little choice: the people of Easter Island, for example, had to rely upon driftwood or timber brought by visiting ships once the island's trees had died out, and many Inuit (Eskimo) groups had only limited supplies of wood available. In the tropical rain-forests of West Africa or Central America, by contrast, vast quantities of different timbers grow. Here, with a wide range of possible choices, local carvers often pre-ferred to use the light, soft and evenly textured woods of the faster-growing trees which were easier to work. Carvers in the African Sahel, however, had far less choice: most local trees, because of sparse and intermittent rains, grew slowly, their wood twisted and close-grained. The carver was often forced to adapt the form of his sculpture to the shape and size of the woods available to him or, occasionally, to use the larger and more evenly textured wood of the giant baobab.

The wood used, however, was not always determined solely by technological factors. In one South Ghanaian group, for example,

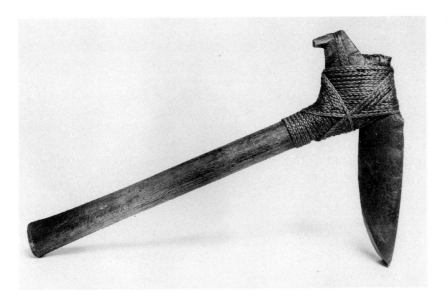

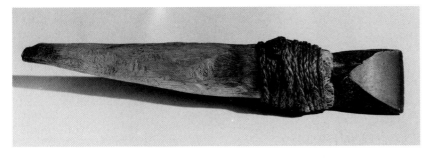

Above (top). This elegant adze from Tahiti was used for wood-carving. The blade is of polished basalt, the tang left rough to increase the grip of the coconut-fibre binding. L. 61 cm.

(bottom). Stone blades which became too worn to be hafted to adze handles could always be re-used as chisels. L. 22.9 cm.

wood-carvings were made in order to control unfavourable spiritual influences. It is said that the wood from which each figure was carved was chosen by the afflicted person who was required to walk with eyes closed until he or she bumped into a tree. It was from this that a piece was cut and given to the carver to work into a suitable image.

Many, perhaps the majority, of wood sculptures were made of unseasoned timber, carved while still full of sap, a fact that often accounts for their subsequent drying out and splitting. According to carvers, such green timber is easier to work than seasoned wood, though in some instances a preference for fresh wood may also have a spiritual purpose, having been taken from a growing, living tree. In none of these societies were saws used before their introduction from the West. Once a tree was felled, blocks or planks were separated from it by hammering in hardwood or stone wedges to split it along the grain; cuts across the grain were made either with axes or adzes.

Such sculpture is reductive, formed by cutting away at a single block. The tool most widely used is the adze, a supremely handy and versatile implement which has almost disappeared in the West. Amongst some peoples straight or curved chisels are also used, as well as a wide variety of knives; but, especially in Africa, the adze is dominant.

The adzes used by sculptors vary greatly in size and weight and, indeed, a single sculptor may use several of different dimensions while carving. The cutting blade may be made of a variety of materials: iron (or nowadays steel salvaged from some broken piece of Western-made machinery), stone, shell, bone or even hard, tough wood. On many Pacific Islands adze blades were cut from pieces of marine shell, the natural curve of the shell often forming the convex outer curve of the blade. In other areas, for example Fiji, Hawaii and the Austral Islands, adze blades were made of hard, close-grained stone. The Maori carver of New Zealand had available sources of nephrite from which to make strong and extremely sharp blades.

The adze shaft, with its acute bend to which the blade is fixed by a variety of methods, is almost always made of wood and usually cut from a point on the tree where a branch springs from the main trunk or a smaller branch from a greater

one. The wood is cut so that the natural line of the grain runs along the length of the shaft and round the angle to form the part which bears the blade. Constructed thus, the shaft is best able to withstand the impact every time the blade strikes the timber being worked.

Techniques of sculpting are in several crucial ways different from those traditional in the West. The sculptor prepares no preliminary drawings (indeed, such a transference from two-dimensional to three-dimensional representation is unknown in most of the societies which concern us here), nor does he plan his work by carving preliminary, and smaller, studies or by modelling maquettes. He works directly, by first blocking out the major masses of his carving and then progressively refining these with smaller and increasingly precise cuts, sometimes using small knives to cut in details. Then, if required, surfaces may be smoothed down with sand, rough, fibrous leaves or, in parts of the Pacific, with rasps made of ray or shark skin.

The adze is generally used to cut flakes from that surface of the block which is directly facing the carver rather than from the edges or silhouette of the wood as occurs with the chisels, hammers, mauls and other traditional tools of the Western sculptor. The adze is swung down against the wood, and the size of the flake removed is controlled by altering the angle between blade and block. Unless working on a large sculpture, the carver usually rotates the block to bring each area beneath the blade as he needs, and the carving may be turned on its side or inverted in order to cut away more easily at particular areas.

Just as no mechanical devices are used to sculpt the wood by these methods, so none are used to hold the block fixed and firm. Unless the block is a very large and heavy one, it is never rigidly positioned in relation to the carving tools. Small carvings are held in one hand, and are often braced against the ground or a block while the other hand wields the adze, or they are gripped by one or both feet and again pushed hard against the ground.

The fact that the adze is generally used to remove wood from the surface facing the sculptor may facilitate the emphasis on mass found in many of these works: the naturalistic tradition of Western sculpture, to some degree at least, goes with the careful shaping of the silhouette. The adze also contributes to the surface texture of many of these works. Here the varying sizes of the small concavities left by the blade's impact serve to lighten and enliven the surfaces and to determine which areas will draw the eye, and which will have a more subdued visual effect. The fact that, in the case of all but large carvings, the sculptor is simultaneously involved in both holding and adzing the wood may also contribute to the characteristic absence of perfect symmetry and total balance of surface finish which is shown in many such sculptures.

The adze, of course, is not the only tool used; in many areas chisels and knives are also found, and, less commonly, gouges. In the Pacific chisels and blades made from sharpened boars' tusks are extensively employed to carve detail. The carvers of the Northwest Coast of North America use a type of chisel or plane, the blade fixed into a handle, which is either struck with a wooden or stone hammer or the ball of the hand. These same carvers also have bent, often two-edged, tapering blades for hollowing out the interiors of masks or vessels and cutting back the outer surfaces of carvings to isolate features from the surface

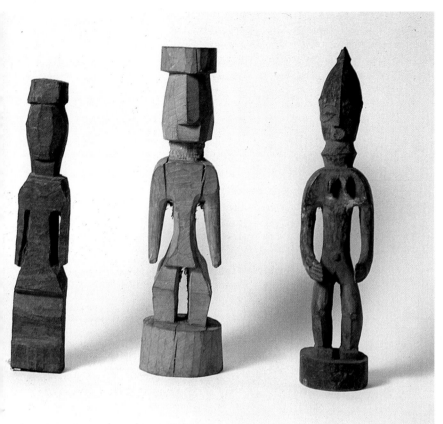
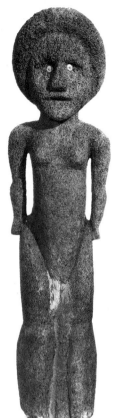
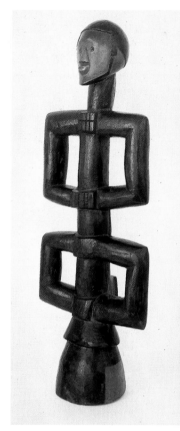

surrounding them. In some areas large masses of wood are hollowed by burning, whilst surface decoration may be achieved by heating metal blades to char the wood. In some societies the contrast between such black charred surfaces and natural wood is an essential feature of the appearance of many carvings.

So far we have discussed the technique of sculpting wood with an adze (in some areas other materials such as soft stone or tree fern are also carved with this tool). Despite the initial emphasis given to wood-carving and adzing it is necessary to stress that sculptures are rarely composed only of wood or any other single material. In the

West there has developed over the centuries a central and dominating tradition of sculpture in a single, durable, 'noble' substance (and especially in hard stone, cast brass or bronze). In many other cultures however, a sculpture is often a combination of different materials of varying durability and strength.

Metal-working

It is rare to find sculpture made entirely of metal. The use of metal for the embellishment of wood sculptures, however, is fairly common, especially in Africa, sometimes using locally produced metal. The Asante

Above. Kings' 'spokesmen' among the Asante of Ghana carry elaborately carved staffs to show their status. They are topped by carving such as this. Staffs and images are covered with gold sheet glued or nailed to them, a technique which allows the production of large objects of great brilliance and richness. H. 22.9 cm.

Opposite. Figures such as these were placed over baskets containing treasured ancestral relics among the Kota of Gabon. The copper and brass sheet was fixed over a wooden form to produce a highly reflective surface. H. 60 cm.

pieces of metal may have been added to sculptures to reflect away any malignant powers. Among the Kota in Gabon, for example, sheets of brass and copper formed the complex surface of highly stylised carvings which were placed over baskets of ancestral relics. Among the nearby Fang discs of brass or round-headed brass nails, imported from Europe, were used for the eyes of wooden figures with a similar function. Here two basic differences in the use of metal are noticeable. In the case of the Kota the metal is the essential element in the sculpture with the complex reflecting surfaces of brass and copper sheet almost entirely covering the underlying wooden armature; in the second the metal is used only to draw attention to a single important area. The first is to all intents metal sculpture, the latter wood sculpture with metal.

Brass-headed nails of the sort used by the Fang were traded in large numbers to Africa, and in several areas served to embellish royal or chiefly property and wood sculptures representing powers or important personages. Among the Songye of Central Africa, for example, large sculptures used to combat mystical dangers often had rows of brass nails and sheets of brass or copper fixed to their heads.

If the above examples are largely drawn from the African continent, this at least in part, reflects the uneven distribution of metal-working technologies outside Europe. Some societies, especially in the Pacific, did not know of metal at all until, in comparatively recent times, they encountered European voyagers and explorers. Among many others metal was often in short supply, sometimes available only through long-distance trade. Metal sculpture, therefore, tends to be confined to relatively few areas and utilises compara-

of Ghana glued or nailed thin sheets of gold over wood-carvings to produce images used to adorn staffs and umbrellas of kings and their officials. The brilliance of the gold and its connotation of wealth added to its role of asserting the ruler's power and pre-eminence publicly. The form of the underlying wood-carving seems to be of less importance than its surface reflectiveness. On the other side of the continent, in the prehistoric culture of Mapungubwe, gold sheet was applied over wooden or bitumen models of animals in similar fashion. As little is known of the makers of these sculptures, their significance can only be guessed at.

The brightness of other metals may have similarly influenced their use as sculptural embellishment among several African peoples: in some areas, it has been suggested,

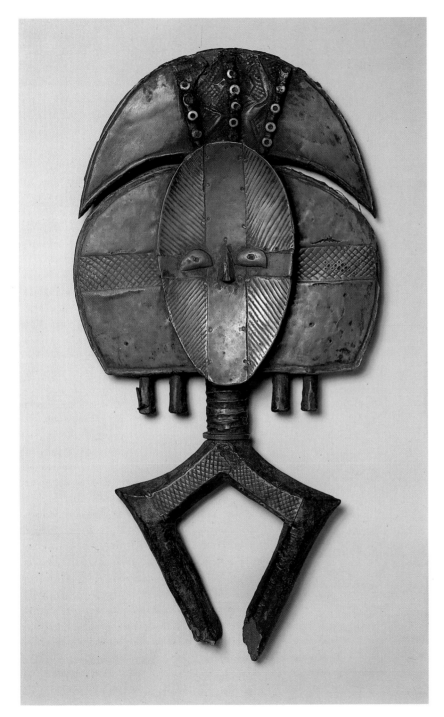

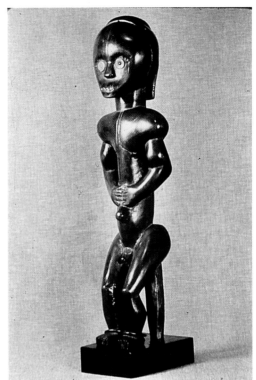

Above. Figure, Fang, Gabon. These figures were placed over containers of ancestral relics. It has been pointed out that whereas the Fang were not unwilling to sell such sculptures to Europeans they would not alienate the relics, an arrangement which suited both parties. H. 60.3 cm.

tively small quantities of what was a precious material. Although many of the cultures of Central and South America developed highly sophisticated techniques for working gold, silver and platinum, the uses to which these could be put were limited and these societies lacked all knowledge of how to produce iron.

To create in metal images which have volume is not an easy task, for by its very nature the metal is far more intractable than substances such as wood or clay. Apart from the method mentioned, of

Among the Bini and Yoruba of Nigeria staffs made of sheet iron are used for various cult purposes. Their forms are closely related to the intractable nature of the material used. H. (max.) 58.4 cm.

fixing a thin and easily-shaped skin of metal over a wooden former, there are two other ways of creating volumetric sculpture. The first is by fabricating images through joining together strips, sheets or lumps of metal, and the second is by melting the metal and then pouring it, while liquid, into a mould of the required shape.

The first method is rarely met. In Africa the Fon of Benin (formerly Dahomey) are known to have made a few pieces of sculpture by joining together sheets of iron, and the Yoruba of Benin and Nigeria also made sculpture for religious purposes from pieces of iron sheet often bent into tubes. The latter sculpture has virtually nothing in common with Yoruba wood-carvings or brass castings: the works in iron tend to have a long vertical format with space and volume created by small pieces of iron radiating from a central shaft. The form was largely due to the fact that the Yoruba could shape and join only small pieces of iron. The Fon seem also to have fabricated a small number of items in sheet silver for royal use, and pieces created in the same general way were made by the Inca of South America and a few other groups of that region. Few of these pieces were more than 30 to 60 cm high.

If the forms which can be created by beating and bending sheets or strips of metal and joining them are limited, an almost infinite variety of forms can be created by casting some metals. Casting, of course, is a combination of two basic operations: the creation of a mould of the desired shape and, secondly, the filling of the mould with molten metal which takes up its shape and retains it on cooling.

The most widely used and the most adaptable casting technique is lost-wax (or *cire perdue*) casting. This can be explained

Lost-wax brass castings from the Tiv, Nigeria, showing various ways in which the wax can be worked to produce elements in the final casting. The bodies, arms and legs have been made of wax rods fixed together and slightly shaped, and features produced by cutting into the wax (mouths), adding small pieces (the central figure's eyes) or by making and forming threads of wax and adding these (the clothing of the figures on left and right). H. (left to right) 16 cm, 23.9 cm, 15.5 cm.

very simply. In it the object which is to be made in metal is first modelled in wax, full size and complete in every detail. The wax model is next surrounded with a thick layer of clay. When this has dried out, it is heated and wax melted out from its centre leaving a cavity in the exact form of the original wax model. Molten metal is poured into this cavity and allowed to cool. The clay mould is then broken away to reveal the metal solidified in the form of the wax model.

In practice the basic process is used with a number of refinements. One or more wax rods may be fixed to the initial wax model: when the latter is covered with its clay encasement, these extend to the surface. As the clay is heated, the rods melt away leaving tubes through which the molten metal may be introduced to fill up the interior cavity. Other wax rods may be used

in the same way to create tubes through which air trapped in the cavity can escape during casting. These 'risers' can contain extra molten metal which is available to keep the central cavity completely full as the metal in it cools and shrinks.

The actual encasement of the wax model also admits of refinement: the surrounding clay may be applied in several layers with those closest to the model being of a very fine mixture of clay, charcoal and water to ensure perfect coverage. Adding finely ground charcoal to these initial layers may also help absorb the air in the mould and any gases released by its contact with molten metal. This helps to ensure that the cast is not spoiled by bubbles trapped in the cooling metal. The layers of clay further away from the wax model can be made of increasingly coarse clay so that the mould is strong enough to withstand the heat applied to it when the wax is melted out, and subsequently when the molten metal is poured in.

The actual mass of metal involved in casting is of great importance. It is essential that this is completely molten when it is poured into the mould and that it stays molten until it totally fills up the space left by the melted-away wax model. There are two basic ways to achieve this. The first is to heat the metal in a fire-proof container until it melts and then quickly pour it into the mould. This is necessarily a dangerous and difficult thing to do. The second method is to place the unmelted metal in a fireproof container and then fix the container to the mould once the wax model has been melted out. The joint mould-container can then be heated in a furnace with the mould uppermost. When the metal is judged to be molten, the mould-container is taken from the heat and rapidly inverted, allowing the molten metal

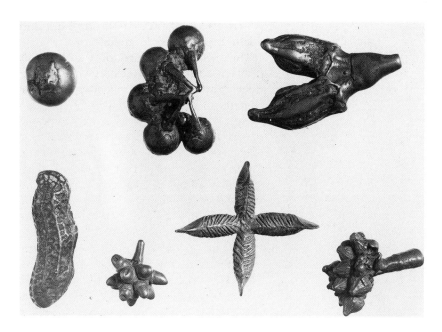

Brass castings which exactly reproduce the forms of seeds and flowers. Such castings, used by the Akan peoples of Ghana as weights for gold dust, were made by encasing a seed or flower in a mould. When the mould was heated, the enclosed object disintegrated leaving a cavity in its shape. Molten brass was then poured into the cavity. L. (max.) 2.9 cm.

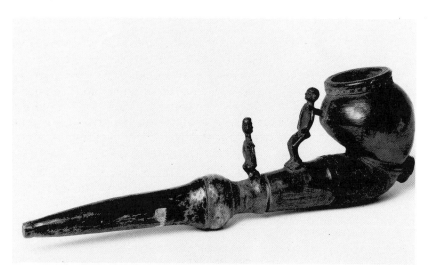

Pipe made of clay but with cast-on metal figures and wood stem, Kongo, Zaire. L. 28 cm.

to rush down into the cavity. This has the advantage that the metal and the mould are the same temperature and the caster does not have to manipulate open containers of molten metal. It has also been suggested that when the mould-container is heated a partial vacuum is formed within and this aids the in-flow of molten metal. The use of this technique is, however, limited by the mass of metal involved: it appears that it is physically impossible successfully to heat, manipulate and invert a mould-container holding more than about 5 kg of molten metal.

Although we have spoken of the *lost-wax* process, other substances are occasionally used in this method of metal casting. In some areas the initial model is made not of beeswax but of a type of latex which is derived from a plant of the Euphorbia family. When this latex is exposed to air, it becomes solid enough to be rolled into sheets or rods which can be made soft and malleable by heating. When encased in clay and then heated, the latex burns almost completely away, leaving a fine white ash. In practice it is virtually impossible to tell from a finished metal casting whether the initial model was made of wax or latex.

It is also possible to use real objects as the basis for casting. The Asante of Ghana, skilful lost-wax casters, occasionally made castings directly from such small items as seeds, beetles, chrysalises and flowers. The chosen subject was encased in the usual way, a wax rod attached to it to provide the tube down which the metal would eventually flow, and the whole heated in a furnace. The original object burnt away to dust and the casting was then made in the usual way by filling the resulting cavity with molten metal. Occasionally such real objects were combined with models made in wax to create an initial composite piece

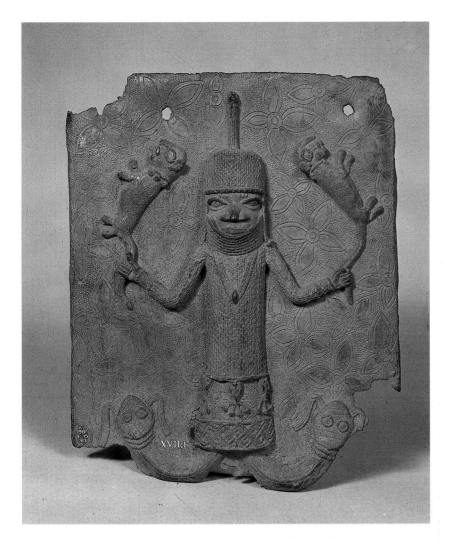

A brass plaque, Benin, cast by the lost-wax method. Such plaques were fixed to pillars on the palace of the monarch. This one shows the king with two leopards, an image of his power. H. 43.2 cm.

which was then encased, burned out and finally reproduced in metal.

The essential feature of the lost-wax process is that it allows the user to reproduce (and reproduce exactly) in metal something made first in wax, a medium which is soft and very easily worked. However fragile and weak the initial wax model is, its form when cast in metal becomes strong and durable. This technique also allows a degree of division of labour for, if required, each step in the process can be delegated to one or more persons.

Most of the lost-wax casting done in the societies discussed here used comparatively small amounts of metal. In the case of gold, silver and platinum cast in Central and South America this is not surprising. but it is worth noting that only comparatively small amounts of brass and bronze were cast in other areas. This must initially have been due to the scarcity and high value of the metal whose use seems often to have been reserved to local political or religious leaders. However, technical factors such as those already discussed also limited the size of castings even when greater supplies of metal became available through the sea trade with Europe. A number of famous brass plaques from the city of Benin, Nigeria, for example, can be seen to have been produced by a number of casting operations, the later ones being done to fill in holes or repair faults in the initial casting. Iron, of course was never cast: the techniques necessary were beyond the technical resources of these societies.

Terracotta

Some features of making sculpture in clay and then firing it are generally similar to those of casting metal: the initial modelling

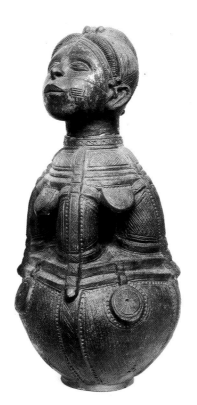

Right. Pot intended for storing water, Zande, Sudan, as indicated by the wide body and narrow tubes connecting to the neck which enable the contents to be kept cool and avoid evaporation. H. 33 cm.

Below. Pots from the Moche culture of Peru seem to depict individuals, possibly approaching the concept of portraiture as it is known in the West. The use of a painted surface over the underlying form allows a delicacy of representation not possible in an unpainted pot. H. (left) 22.5 cm; (right) 18.5 cm.

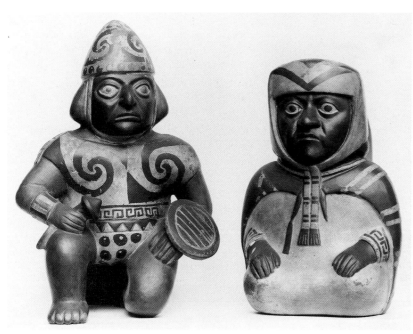

is done in an easily worked material and this is then subjected to processes that render it more durable. Clay, however, cannot be made into such delicate and complex forms as wax, and terracotta sculptures usually have a rather stolid look to them, especially when compared to cast-metal works but even by comparison with wood-carvings.

Although many small-scale societies make pottery vessels, terracotta sculpture is relatively rare. Where it is found it is often made by a special class of people rather than by those who make vessels and other pottery wares for everyday use. The techniques of sculpting in clay are fairly straightforward: at their simplest they may consist of only adding a few features to a pot made in the usual way and not yet fired. This can be done either by adding small shaped pieces of clay to the vessel, dampening either or both surfaces to create a good bond or, more simply still, cutting the required features into the unfired surface of the vessel. A third method is to paint features – usually human features – on to the vessel in a slip of different coloured clay. Equally, where the vessel itself is to be coated with slip some parts may be treated to prevent its adhering at those points, or the required features may be created by removing parts of the slip subsequently.

More frequently, however, the sculpture is modelled as a separate entity rather than created by modifying an existing form. Here there are two primary limitations on what can be made: firstly, the clay must be able to support its own form before it is fired and, secondly, the sculpture must be capable of being fired without suffering serious damage.

The techniques of sculpting in clay vary considerably but most take advantage of the basic plasticity of the unfired material;

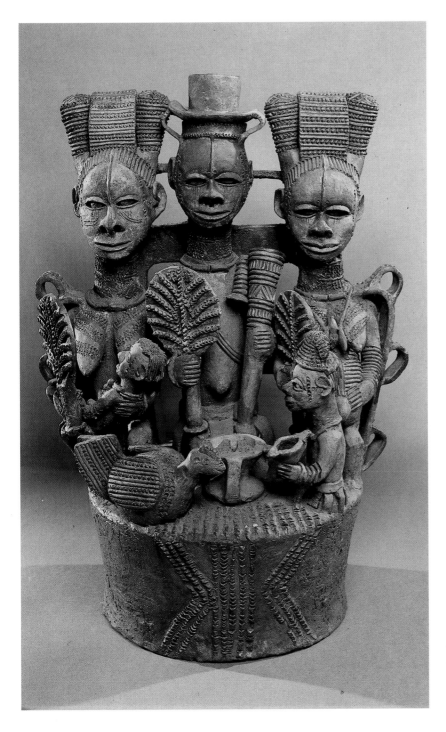

that is to say the image is modelled in damp clay rather than carved out of a drier mass. Usually the image is built up by adding one lump of clay to another, often starting with a central piece which forms the 'body', and shaping the other pieces round it with the fingers or simple tools. To shape a head, therefore, the sculptor can either pull out the main features from the clay or model them separately in other pieces of clay which are then stuck on. Alternatively, they may be impressed with a piece of wood or metal, or even gouged out with a finger-nail. The point is, however, that it is usual to carry out most or all of this shaping before the clay is allowed to dry out and harden as the necessary prelude to its firing. Only in rare cases is the dried 'leather hard' clay carved or incised as a way of forming the sculpture.

The degree of elaboration and the size of the sculpture are limited by the fact that the clay is, at the unfired stage, relatively weak. This means it is impossible to create delicate free-standing elements, like long thin arms sticking straight out from the body, simply because these would collapse under their own weight. Equally, after a certain point it becomes impossible to fire a solid mass of clay for, on firing, the water in the clay at the centre of the mass will be released as steam and this, unable to escape, will blow the clay apart and destroy the sculpture. Where comparatively large forms are to be made, they therefore have to be hollow, or have one or more

Pots of this type were made among the western Ibo of Nigeria for a cult connected with the growing of yams, a staple food. The figures represent family heads, their wives and attendants. Such elaboration of pottery is almost always indicative of an exceptional function. H. 48.3 cm.

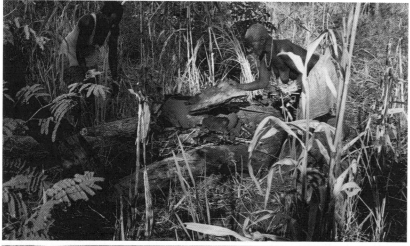

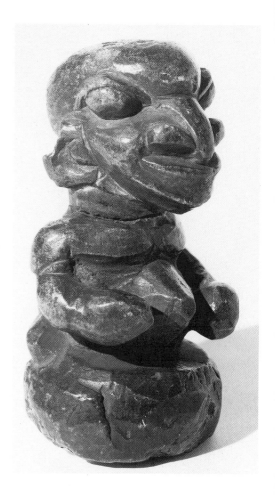

holes running from centre to surface to allow for the escape of steam during firing. Terracotta sculptures for this reason often tend to be rather small and dumpy and have few free-standing features.

The clays used by potters in small-scale societies are often rather coarse: they contain considerable amounts of grit and sand. This, it appears, is advantageous because it allows the pot or sculpture made from such clay to be subject to considerable local variations in temperature without cracking. This is especially important not

Above left. Pots being fired, Moru, Sudan. Here the 'kiln' consists simply of the branches of a felled tree so arranged as to provide walls on all but one side and stacked with bark chippings to provide the fuel. Many of the firing processes in the areas discussed are little more complicated than this.

Above right. Figure in soft stone, Sierra Leone. Such carvings were made several hundred years ago and their meaning is unknown. Because they endure, however, local people who find them place them in shrines to assist the fertility of their fields. H. 10.7 cm.

Opposite. Stone figure, Easter Island. Such figures were set up on prominent sites overlooking the sea, usually with 'top knots' of a contrasting colour. They were cut horizontally from the quarry face before being dragged into position and erected. Such vast projects, requiring great communal labour, are rare in small-scale societies. H. 294.6 cm.

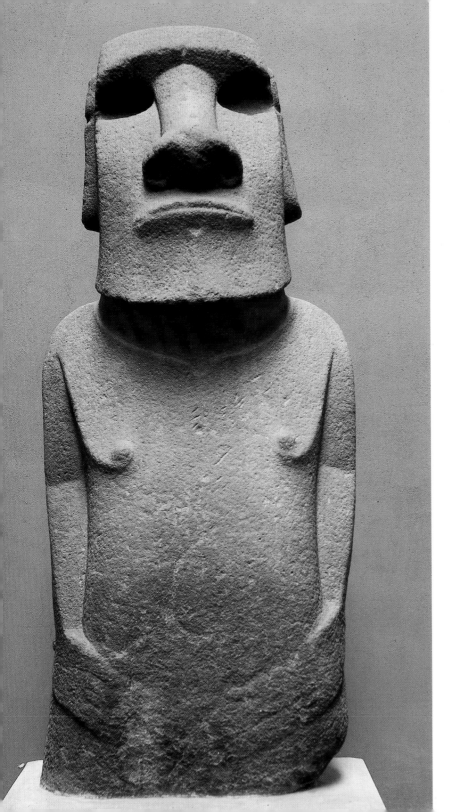

only because vessels in everyday use may be heated unevenly on cooking fires, but also because it is usual to fire such pottery in what is little more than a giant bonfire: the pots or sculptures are placed on the ground, dry wood and leaves heaped over them, and the fuel set alight. Close examination of sculptures fired in this way will often reveal that only the clay on or near the surface has actually been fused by the heat; that in the centre is still in separate grains.

Stone-working

Sculpture in stone is comparatively rare in the societies under discussion, and the sculptural forms produced in this material relate directly to the hardness of the raw material and the tools and techniques available to the sculptor. Indeed, the comparative rarity of such sculpture may be largely due to two factors: the existence of alternative materials which are easier to work, and the fact that, where permanence is not a desired characteristic, there would seem little point in working in stone. Nevertheless, stone sculptures often of great size, have been produced by comparatively small groups, as in the case of Easter Island, where a high value seems to have been placed on the creation of long-lasting images.

The types of stone used vary greatly in hardness. Among the prehistoric peoples of Sierra Leone, for example, local supplies of soft soapstone were carved. This material, which has an even texture, is easily worked with an iron blade. The technique used seems to have been similar to those later used in carving wood in the same area: the main volumes of the sculpture were blocked out first and then progressively refined. The durability of such small

images gave them another usual characteristic: many were re-used, centuries after their creation, in new contexts and given new significances. Thus the peoples who now live in this area are accustomed to finding such stone images while cultivating their fields. They place them in shrines and make offerings to them to solicit good crops.

On the Northwest Coast of North America supplies of soft even-grained argillite, a sort of shale, were discovered early in the nineteenth century. This material hardens gradually on exposure to air: when freshly dug it is easily carved into elaborate forms, and the making of these, especially for sale to European traders and sailors, developed rapidly after the initial discovery. Here the styles and motifs were largely derived from ones earlier used in wood-carving or painting on flat surfaces; their transfer to argillite allowed the elaboration of these in miniature.

Much stone sculpture, however, is far less elaborate, consisting of little more than the simplest modification of a natural form, often done by pecking with a harder stone or by grinding. These laborious techniques are also used in some areas to work particularly hard stones such as granites. By and large the hardest of stones, such as jades used in New Zealand or Central America, can only be worked by abrading them. Pieces may be cut out, or straight lines incised, by continually rubbing an abrasive across the surface with a sawing motion. Circular motifs are made by drilling with a hollow shaft, turning it in an abrasive. Here it is extremely difficult to create forms which have a volumetric character; instead, such sculpture shows an attention to outline with a few shallow features cut or drilled into the surface, often only on one face. Other materials may

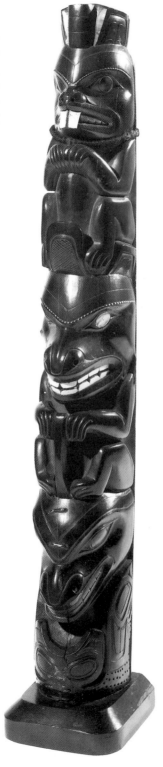

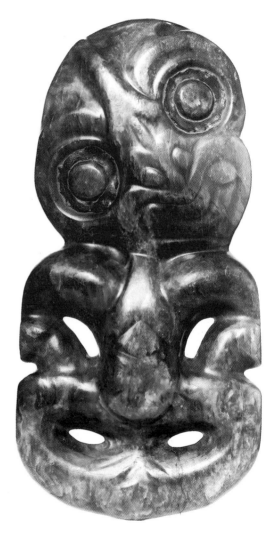

Far left. The large wooden 'totem poles' of the Northwest Coast of North America were later produced in argillite (a sort of shale) as part of an early tourist art. H. 54 cm.

Left. Greenstone pendant (*hei tiki*), Maori, New Zealand. The hard stone was cut into with abrasives and then polished. Many *tikis* seem to have been shaped from disused adze blades. H. 20.3 cm.

Right. Stone figure, Cross River area, Nigeria. Large sculptures in stone were rare in Africa. Works such as these, of unknown date, seem to have been made to commemorate leaders. There was little shaping of the hard stone: features were ground and pecked into boulders whose natural shape needed little modification. H. 66 cm.

Far right. Stone pestle, Papua New Guinea. The date of this excavated pestle is unknown, but it is remarkable not only for its complex and graceful form, achieved without metal tools, but also for the ambiguity of what is depicted, an image at once bird-like and phallic. H. 35.6 cm.

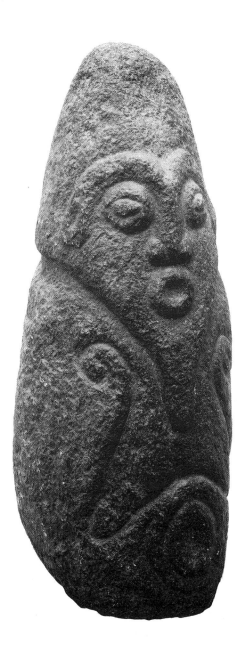

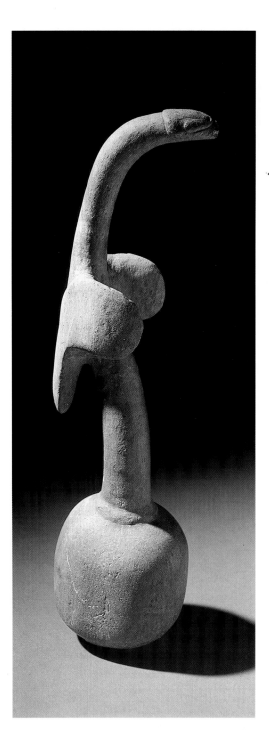

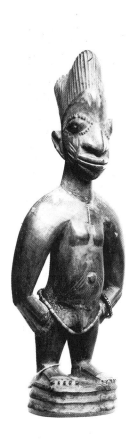
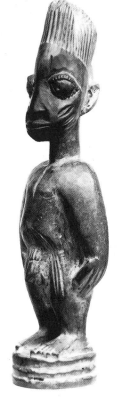
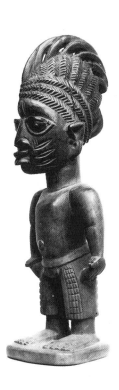
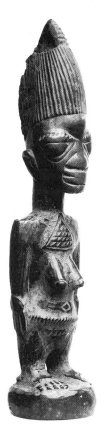
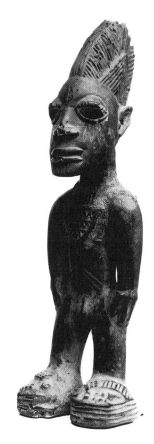

Ibeji (twin) figures, Nigeria. These five carvings indicate something of the varying styles of individual Yoruba carvers and the existence of local sculptural traditions. The central figure has had little wear, but the others show how sculptural form may be modified by use (and, in the case of the figure on the extreme right, by insect damage). H. (max.) 28 cm.

be inset to represent particular features or to bring variety to the surface.

Such sculpture, however it is created, is in the broadest sense made to be used. Whereas in the West a work of sculpture has usually been intended to endure unchanged for long periods, this is rarely the case in the societies under consideration, for many images once manufactured are still far from completed. Often they continue to be altered in one way or another long after they have left the hands of their makers. Over the years their appearance may change almost beyond recognition. The converse also occurs: a work of sculpture may be allowed to decay by natural

weathering or the activities of insects with no attempt to prolong its life unchanged.

At the simplest level changes in sculptural form may arise from the periodic refurbishing of a work: masks may be repainted for annual festivals and, where elements have become worn or damaged, new parts may be attached. Similar in effect is the addition of substances which are thought either to beautify a sculpture or which are connected with some rite or process in which the sculpture is used. The Yoruba of Nigeria and the neighbouring Republic of Benin, for example, carve small dolls which serve as surrogates for deceased twins. The mother of a dead twin will carry a doll on her back, as she would a

Two-headed dog, bristling with nails, blades, hooks and bells, Kongo, Zaire. Such images, more often in human form, are used by magical specialists in casting spells deflecting illness and evil, and determining guilt. The method is to drive the blades into the figure which over time amasses a coating of metal. The magical substances caked on the back are designed to activate the powers inhering in the image. L. 61 cm.

living child, sometimes offering food to it or even washing it. In this way the wood becomes polished, the features worn away. The twin doll may also be decorated with red camwood and dark blue indigo and, over the years, may become so thickly encrusted with these substances that the original form of the carving is partly obscured.

The most extreme cases of this evolution of form occur when large quantities of material are added to a piece of sculpture because of the powers it and the added material are believed to embody or represent. This is particularly so in certain parts of Africa where the original sculptural form serves as little more than a support or armature for later additions. Among the Kongo of Central Africa, for example, a class of carvings are employed by suppli-

cants who seek the help of the supra-human powers they embody. Prayers, supplications, oaths and offerings are signalled by hammering an iron nail or blade into the surface of the sculpture. Eventually the sculpture may bristle with these to the extent that the original form is completely lost. After a point such sculpture generates its own evolution of form: the more nails people see stuck into it, the more powerful it is considered to be and, therefore, the more it attracts offerings of the same sort. Also in the Central African area many pieces of sculpture are empowered by the addition of magical, powerful materials. Sometimes these are contained in animal horns, sometimes they are made into a thick paste and cemented to the head or belly of the sculpture. In such cases the form of the sculpture is the result of the

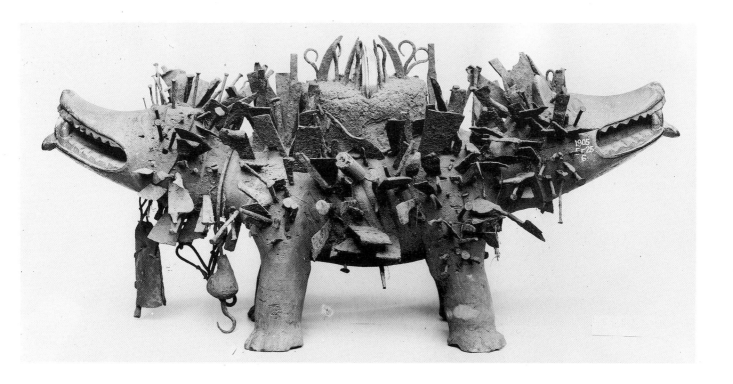

Right. Solomon Island figure. The characterisation of a particular social position is achieved not by any attempt at a physically exact likeness but by decorating an image showing the appropriate facial·markings and ear-plugs with actual items of male adornment. H. 53.8 cm.

Below. Figure used on behalf of a village to counteract malign influences, Songye, Zaire. Empowered by the addition of magical elements (amongst them a medicine horn, human teeth and feathers), such figures are said to be manipulated only by the use of long poles. H. 41.4 cm.

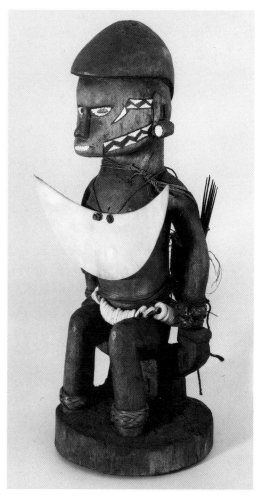

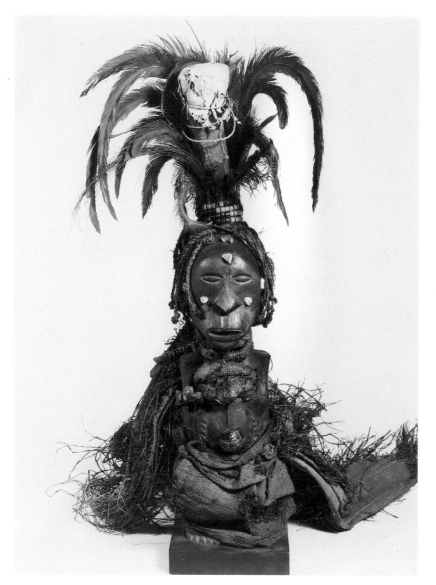

work of at least two people: the carver who initially shapes it and the mystical specialist who prepares and adds the magical or medicinal substances. A work which is deemed successful in bringing about the ends desired may, during the course or its life, have added to it additional materials: mirrors, bells, horns and so forth. Here social action has taken over from technological process in the creation of sculptural form.

3
The artist and the image

It will be clear from the foregoing survey of technological processes that there is very considerable variation in the degrees of complexity involved in the production of sculpture. Whilst anyone in theory might with more or less success attempt to carve an image in wood, it clearly requires a considerable investment in training and expertise, not to mention access to scarce materials and specialised equipment, to work in metal: a beginner cannot simply pick up the raw materials, a readily available implement, and start work. Inevitably there will be wide disparities in the status of artists and the evaluation of their works within and between societies, as there will be in the qualities of mystique attaching to their crafts. No simple formula or single set of regularities characterise the artist's position in non-Western societies.

Perhaps the greatest contrasts are to be found in the areas of professionalism and specialisation. It is certainly the case that virtually nowhere is the creation of sculpture more than a part-time activity, for, even if renumerated in kind for his work, the artist will in most cases have other activities − often those of basic subsistence − to perform or organise. Amongst the Asmat of New Guinea, for instance, if a sculptor is approached to produce a large-scale work, one of the conditions of his acceptance is the provision of labour to take over his responsibilities for the preparation of sago and his participation in hunting and fishing expeditions. Even those artists elsewhere who work under the more regular and reliable patronage of a traditional ruler and court will normally have their own land to be cultivated and tended. Equally, no traditional artist in these societies is likely to produce sculpture unless specially commissioned to do so − it would be wrong to envisage such artists as pursuing some essentially private vision regardless of public demand. Nevertheless, there remains a substantial difference between the Asmat wood-carver and a member of, for example, one of the craft guilds in the Nigerian kingdom of Benin.

Amongst the Asmat every man as part of his upbringing is familiar with the techniques of carving: he knows which woods to use for particular purposes and is expected as an everyday skill to be able to provide his immediate family with all their wooden domestic utensils. He may even undertake more major projects such as carving canoes and paddles. The sculpting of large ancestral poles, however, is another matter. For this only those who have shown particular aptitude at carving and interest in this more specialised work are commissioned. Normally the request comes from members of the artist's own kin group, with whom, of course, he shares the common ancestors in whose honour the work is undertaken. Such carvings are accorded a distinctive title. However, no special training is needed to qualify for selection as a specialist sculptor; no elaborate ritual preparations surround the process of carving which takes place in the open and not secretly; no set form of payment is available; and the carver himself is not particularly singled out by his work. He is esteemed, as the Asmat would have esteemed a successful head-hunter, but in every other way he is and remains an ordinary person sharing the same values and concerns as everyone else.

The demand for ancestral images amongst the Asmat is relatively small − certainly by comparision with the demand for art-works generated under some of the centralised state organisations found in other parts of the world. These works may be of several sorts: objects for use in state

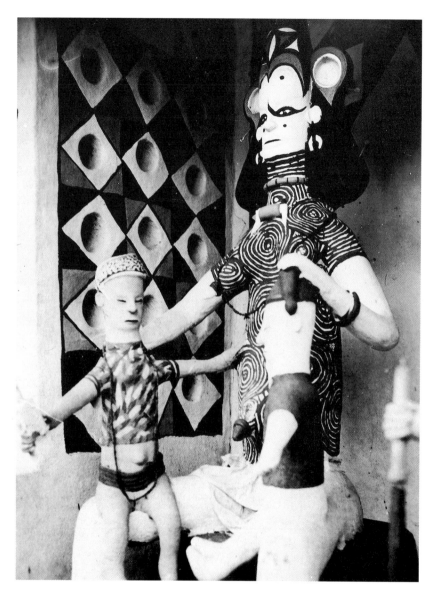

Clay figures from an Ibo *Mbari* house, southern Nigeria. The importance of such large tableaux lay more in their creation than subsequent preservation.

rituals, for instance, or for the enhancement of prestigious court or kingly office. The very quantity of such commissions in the more elaborate of kingdoms often sustains the organisation of craft production into a series of distinct artisans' guilds. Benin is a good example.

At the height of its development the city of Benin contained a number of separate and distinct craft groups: brass-workers, sculptors in wood and ivory, blacksmiths, carpenters, leather-workers, weavers and the makers of costume and beadwork. Typically these guilds were organised in such a way as to distinguish their membership from society at large. For example, the carvers, like several other guilds, all lived together in the same quarter of the town and were related to one another by ties of kinship. They held a monopoly on all carving (anyone else executing a carving in wood or ivory was subject to the penalty of death), and their skill was considered to be inherited within the guild. The process of carving took place out of public view, more important works being carved in a room specially set aside for the purpose within the palace itself. The artist did not simply emerge somewhat randomly and untutored as amongst the Asmat and like peoples; from an early age guild members were taught the techniques of carving by their fathers. As his skill developed, the child progressed into one of the higher grades within the guild, the senior members of which exercised a supervisory role in relation to their juniors and ensured the quality of the work produced.

By residence, kinship, occupation and skill, therefore, the members of Benin craft guilds were set apart. This was further emphasised by the ritual context within which the process of production took place. In the case of the carvers offerings

had to be made periodically to their tools in order to prevent them from becoming 'hot' and possibly causing injury to their users. The carver also had to prepare himself ritually for the act of carving. If, for instance, he had slept with a woman, he was required to bathe and change his clothes before beginning work. Much of this still forms part of the secret ritual life of the palace and is not generally seen by non-guild members. Significantly, however, if he is obliged to work outside this setting in one of the surrounding villages, prohibitions normally limited to the carver alone are extended to the villagers with fines imposed for violations. For these reasons then, Benin carving has been described as a ritual process rather than simply a mechanical, albeit artistic, act. The same observations can be applied to several other Benin craft guilds.

Such enclosed, socially and ritually separated, groupings of craftsmen are a common adjunct to court systems; yet it is by no means only where state formations exist that artisanal guilds or something closely equivalent occur. Blacksmiths, for example, are frequently set apart as an occupational class regardless of the characteristics of the society concerned. Often their own traditions of origin indicate that they are ethnically distinct from the peoples amongst whom they are living and working. Ritual and economic mechanisms usually operate to stress this separateness.

As already mentioned (see p.24), blacksmithing as opposed to casting gives rise to fewer innovations of a broadly sculptural kind in the working of metal, though smiths may often provide the tools with which sculpture in other media is executed. Blacksmiths, nevertheless, frequently hold a monopoly over the material production within a particular society. In many parts, especially West Africa, blacksmiths are also wood-carvers, whilst the women of their group, female 'blacksmiths', have a monopoly in the production of pottery. The price of this control of production, however, is exclusion from the reproduction of the wider society in which they live, for blacksmiths are usually endogamous, marrying within their own occupational group.

In being classed differently from other people blacksmiths are rarely credited with high status. Only in some parts of Central Africa is smithing regularly associated with access to power in the political field,

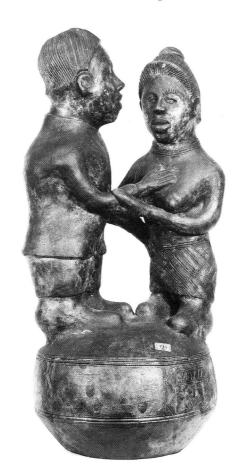

Figurative pot, Woyo, Zaire, signed by the maker, Voania Muba, a rare instance in which the artist's name is known. He appears to have worked exclusively for a European clientele and frequently depicts colonial scenes (the act of signing work is itself an indication of European influence). An obscure figure, he came closer to the European notion of the artist than many working in a more traditional context: he worked alone, in seclusion, and had no formal training. His work was sold at the ports on the Lower Congo by intermediaries, he himself preferring to remain in his own village where he was a customary chief. H. 45 cm.

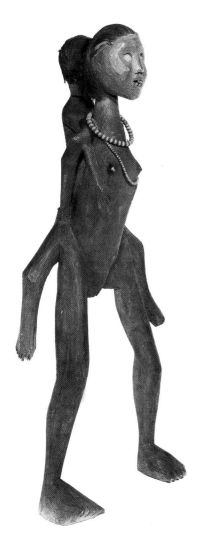

Wood figure, Malawi. Maternity is commonly portrayed in female figures, the relations of mother to child often being used as a metaphor for other kinds of political and cosmological relationship. Frequently the child is depicted being nursed; here it is shown carried on its mother's back. H. 66 cm.

though chiefs or kings are no longer practising smiths. Generally, however, their separation as a group leads to their being accorded a lowly social position, their involvement with technological processes being considered dirty, or 'hot' and dangerous. Even craft guilds working closely within a court system are not, for all the access they have to channels of influence, of the highest status. In Benin membership of an artisanal group places a person above a farmer, but as a manual worker his prestige could never equal that of a chief, native doctor or warrior. Indeed, one of the more general characteristics of the artist in traditional societies is that however valued his works, however essential, practically or ritually, his own standing is not necessarily of corresponding magnitude. It can, in fact, be exactly the reverse: his products are prestigious, he is of dubious status; the objects he makes are incorporated into society at large, he is excluded.

The sculptor may be recruited simply on the basis of aptitude or willingness, or his skills may be inherited and cultivated from an early age; he may be specialised in one medium or versed in several; he may work in private or in public, more or less open to, and responsive to, criticism; he may work in an atelier with other artists, several people perhaps involved in manufacturing a single object, or he may be alone – all of this in addition to differences between artists in terms of personality, cultural background and ability. Only two features seem to be of wide applicability. Firstly, the artist never seems to be an isolated individual, living on some 'bohemian' fringe of society and exercising a critical and innovative function. Even blacksmiths or more formal craft guilds are formed into groups with their own internal organisation, and they enter the life of the wider

society in which they live in a regulated fashion. Secondly, the creators of sculpture are almost invariably men. Women particularly female societies, often commission sculptures and frequently display it. They may well have a role to play in the preparation of the raw materials and sometimes in the subsequent decoration or embellishment of sculpture. Yet the dominant part in the production process is reserved to men. The logic of the situation often seems to be that men produce sculptural images; women produce children. And women, of course, often as a result of this child-bearing capacity, provide the sculptor with one of his leading subjects.

Figurative sculpture

In Western art we are used to sculpture, and paintings, which represent individuals; the societies discussed here, however, have very different traditions. There is rarely a direct association to be made between the form of an image and that of a particular living individual; indeed, for the most part specific living persons are not regarded as suitable subjects of sculpture. Sculptural images may represent, instead, deceased ancestors, guardian spirits and lesser gods, or they may in some cases give form to the yet unborn. Even where there is a close conceptual association between a living being and a sculpted image, the image may not represent people as they are, but, rather, a sort of non-physical twin, a non-substantial *alter ego*. Equally, sculptures may represent some non-physical aspect of a person – their fortune, their innate power or the success they have achieved by their own strivings. Pure abstraction, however, occurs hardly at all.

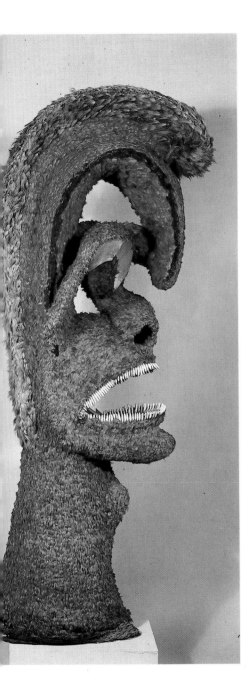

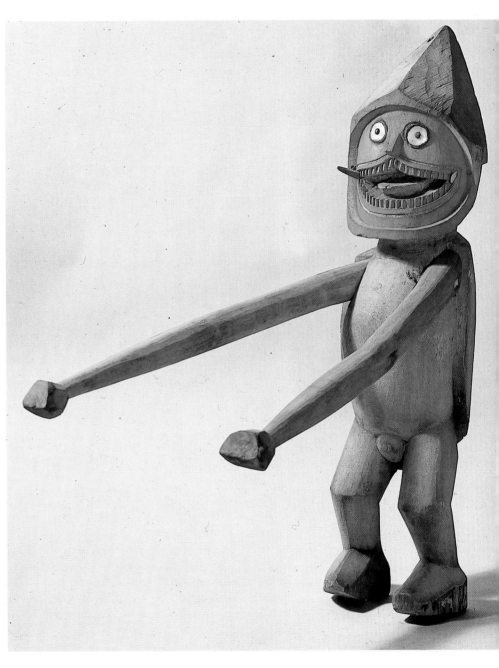

Hawaiian basketry and feather image of a god. The eye was indicated with pearl-shell and the teeth with dogs' teeth. H. 61 cm.

One role of the image is to mark, or give physical form to, an invisible boundary between one realm and another. In the Nicobar Islands images such as these were erected to protect people from the intrusion of dangerous forces or entities. H. 75 cm.

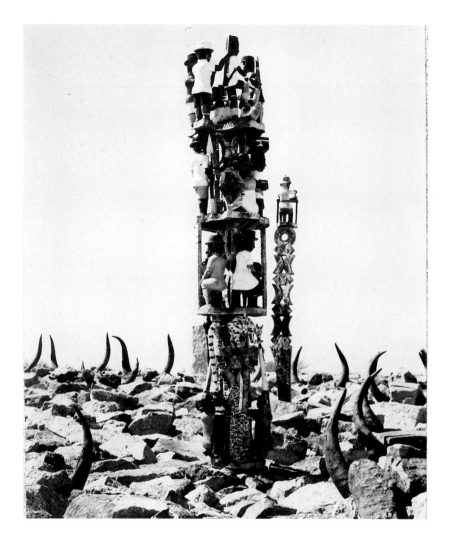

Wooden grave marker, southern Madagascar. The deceased is commemorated by sculptural references to the events of his life rather than his physical features. The horns implanted in the grave are those of cattle slaughtered at his death, an indication of his wealth.

There are relatively few societies in the areas under discussion for whom it has been claimed that their traditions of figurative sculpture owe very much to an attempt to create the likeness of particular persons. Traditions of portraiture are simply not a prominent feature of these cultures, nor do they assume the same significance they do in Western art. Even the apparent exceptions turn out on further investigation to be portraiture only in a rather special and somewhat divergent sense.

For instance, one of the most quoted examples of portraiture in this field are the figures of kings carved by the Kuba, a people with a powerful and durable kingdom who live on the southern fringes of the African Equatorial forests in present-day Zaire. According to Kuba ideas, one of these statues was carved during each reign to commemorate each of the kings in an unbroken line of dynastic succession which stretches back to the opening decades of the seventeenth century. These figures (ndop) were regarded as the doubles of their subjects, as repositories of kingly power, and were revered in terms closely similar to those otherwise reserved to the king himself. There are, however, difficulties with these indigenous theories. In practice it seems that, even given that some dynastic 'portraits' may not have survived into modern times, many kings were never in fact the subject of a ndop. More seriously there are also clear indications that those images which have survived were not necessarily carved during the lifetimes of the kings they represent, or even shortly after their death, despite the belief that they are direct portraits carved from life. Indeed, it is highly probable that the older surviving figures are the work of possibly as few as two artists, despite the fact that the reigns of the kings whose likenesses they are reputed to be span a period of several centuries.

In effect, the Kuba tradition of king figures fails to meet what in Europe would be the crucial criteria of portraiture: that there should be a sitter and that the image created of him or her should present a reasonably accurate record of what they looked like at a particular time in their life. In each case the Kuba 'portraits' show their

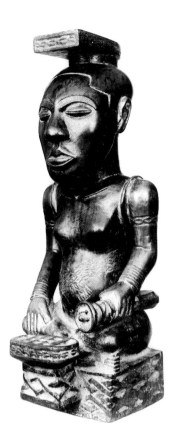

Such wooden figures were made to commemorate the kings of the Kuba people of Zaire. Different rulers were represented by virtually identical images, and there was no concern to delineate accurately the physical features of individuals. H. 55 cm.

subject in the same cross-legged posture attired in identical ornament and carrying the same items of regalia, a combination which is exclusively the ceremonial wear of the king. Portrait painting in the Western tradition, of course, does much the same as this: it presents its subjects not as individuals but rather as individual monarchs or clerics or landowners. They too are presented in contexts appropriate to their role. Yet unlike Western portraiture the Kuba dynastic figures are invested with no physical features by which to distinguish one individual from another — certainly they show no physical blemishes, and indeed they cannot do so because kings by definition are meant to be physically perfect.

Ultimately it is not the carved figure itself with its idealised picture of royalty which permits identification of each statue with a particular king and reign. Instead, it is a small emblem carved on the plinth on which each figure is seated. For the Kuba this is as unmistakable a guide to royal identity as the king's name or for that matter his physical appearance. Each king selects an image by which to commemorate his rule — a game board, an anvil, drums — and these items carved on the *ndop* are the signature of the sculpture's subject. In Western painting portraiture expresses identity, social position and individuality; and the Kuba figures do this also. They achieve their ends however, not by concentrating on the physical details and distinguishing marks of the figure itself but by these small yet highly significant differences in the context within which each figure is placed.

The use of such abbreviated signals to associate sculptural form with particular individuals is relatively widespread. In masquerade, for instance, it is not uncommon for well-known local figures to be variously lampooned or lauded in the course of performance. The practice is an established one in several parts of the world — amongst the Ibo of Nigeria, for example, in Zaire and Angola, and in parts of Latin America. Yet in these cases, again, it is usually not the characteristics with which the mask or indeed the associated costume have been invested which individualise the portrayal; it is often some idiosyncrasy of gesture or style of movement reproduced by the masquerader that identifies the victim of the impersonation. While the effect is to individualise sculptural form with results entirely analogous to those of European portraiture, the method is the exact reverse: here it is the particular context which lends the mask its identity (Ibo masks, after all, as elsewhere, conform to largely unvarying criteria of style); in the painted or sculpted portrait by contrast the context is general (the trappings of kingship, religious office or wealth) but the subject individual.

In these cases, therefore, we are not dealing with traditions that precisely agree with our usual expectations of portraiture. In some places, however, a much more complete match has been suggested. Many so-called 'portrait masks', for example, were collected from the early nineteenth century onwards by travellers and traders, from such groups as the Kwakiutl, Nootka, Haida and Tlingit living along the Northwest Coast of North America. However, almost all of these were made specifically for this market, an early example of an art form shaped to suit the expectations of the tourist. Traditionally, such masks were usually associated with spirits or with ancestors rather than with actual living individuals and, indeed, were generally brought out and used in circumstances

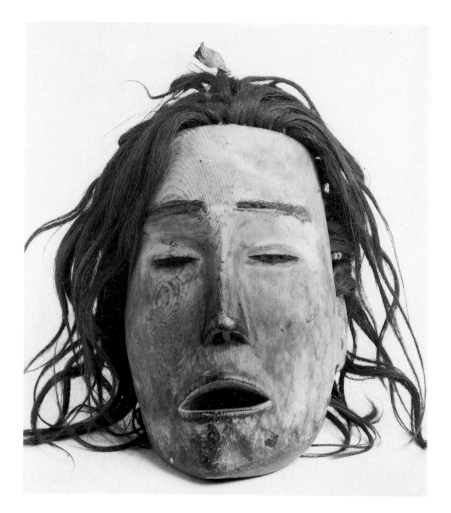

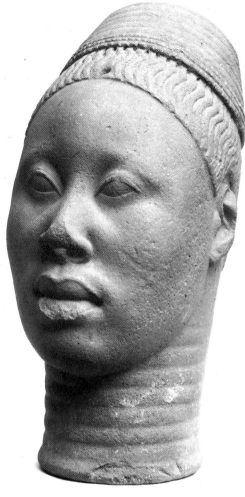

Above. Carved wood human head, thought to represent a dead person, Nootka, Northwest Coast of America. It may have been used in a type of dance during which the dancer appeared to be beheaded. H. 33 cm.

unfavourable for viewing them with the attention to detail portraiture requires. They were worn at feasts which took place indoors, in winter and at night, the performers lit only by firelight. It would appear that it was at the behest of Europeans attracted by the apparent realism of some masks of the more traditional kind that portrait masks came to be made at all.

It may be that the closest parallel to the Western notion of portraiture is found not in the practice of creating external images,

whether sculpted or painted, but rather in actions carried out in various parts of the world upon the body itself. The most obvious instance of this is mummification which seems to give permanence to physical features by arresting decay. In the field of sculpture very life-like effects are achieved by over-modelling the skulls of the dead, especially in parts of Oceania. The skulls themselves may be disinterred and dried or picked clean by ants before the original human features are recreated

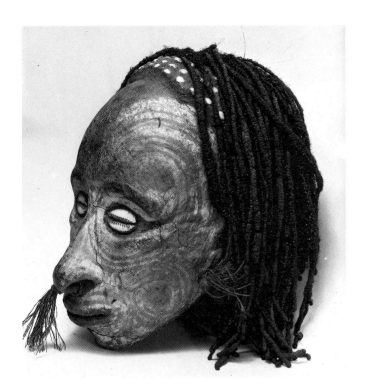

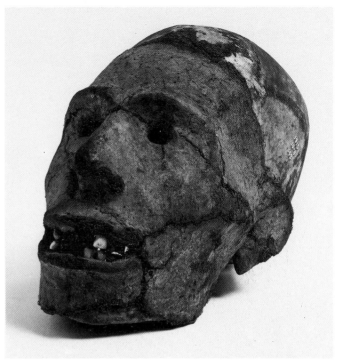

by an overlay of plastic materials. In New Guinea the modelling is generally worked in clay, and in the New Hebrides and New Britain a vegetable paste is applied. Whilst the resultant portrayal may record with considerable accuracy the physical appearance of the deceased, the additions of facial ornaments, tattooing and other distinguishing features help locate the ancestor thus honoured. The practice itself is associated with a belief that so long as the human corpse or in this case parts of it retain a recognisable form they remain a potent and animate force.

To ask why portraiture in its proper sense is so rare a feature of traditional societies in the non-Western world is perhaps as pointless as to ask 'what would have happened if...?' of historical events.

Any response can at best be only partial and conjectural. It has been argued that some cultures have possibly shunned a naturalism that moved in the direction of portraiture through fear on the artist's part of being accused of witchcraft: to create an exact image of someone is to create the possibility of exerting power over him. Such ideas are liable to have a certain currency on the fringes of the Islamic world whose traditions, of course, discourage representational forms. This explanation, however, assumes a disposition to create portraits in the first place and a deliberate decision not to pursue that course. In practice such a senario is most unlikely; it looks much more like a rationalisation intended to keep the eager European enquirer happy than a genuine de-

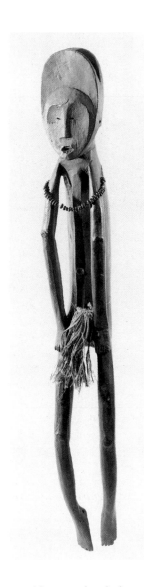

Wood figure made to be hung in the meeting house of a secret society, where it is said to have replaced the actual body of a transgressor against society rules. This attempt to render sculpturally a hanging form is unique in an African context to the Bambole, Zaire. H. 120.7 cm.

scription of the situation. In any case since a lack of portraiture is so general a feature of non-European imagery, local explanation can hardly be expected to hold for the innumerable other instances.

One final point worth making in this context is that the ways in which images of the self are created in such societies have until relatively recent times differed significantly from those of the Western world or classical cultures elsewhere. These are not societies which as a rule possessed amongst their domestic artefacts the familiar device of a mirror. Reflective surfaces of course existed — water for one — but to see oneself regularly and with clarity of definition was exceptional. In almost all cases where elaborate coiffures or facial markings were popular a person did not apply these to his own body, and particularly not to his own face, but had to enlist help. The result could not be checked directly either.

This also helps explain why in figurative sculpture it is detachable elements associated with the body — items of jewellery, charms or costume — which are expressive of identity rather than direct physical features. It is the office (or, more broadly, the social state) a person occupies which is thereby portrayed, rather than the office holder as an individual.

The lack of a one-to-one association between sculpture and living beings is also connected to the fact that these traditions are non-naturalistic: the makers of such sculpture are not concerned with representing the shapes and relative proportions of the human body with any degree of accuracy. The contrast with much of Western art is strong. For many centuries there has existed a convention to use an illusionistic accuracy in depicting the human form. In order to do this the Western artist has relied heavily on a detailed knowledge

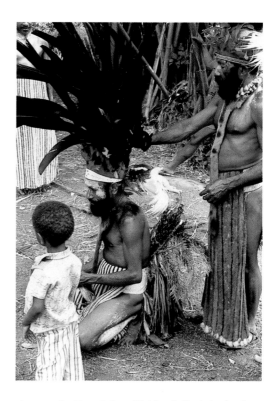

Above. In the New Guinea Highlands the introduction of mirrors has allowed a person to check and apply much of his own decoration. Such tasks as the placing of feathers in a head-dress, however, continue to be carried out with the assistance of a second person.

Right. Brass head representing a queen mother and dating from the 15th or early 16th centuries, Benin, Nigeria. The distinctive long-headed cap covering the hair is associated with this important title in the Benin kingdom. H. 39 cm.

of anatomy and, by accurately delineating muscular tension or the contrast between flesh and underlying bone, he is also able to use the body expressively. In this tradition, therefore, not only can individuals be depicted by reproducing accurately their physical characteristics, but a more or less naturalistic depiction of the body can be used to express particular human emotions or states, whether of grief, ecstasy, or simply, age.

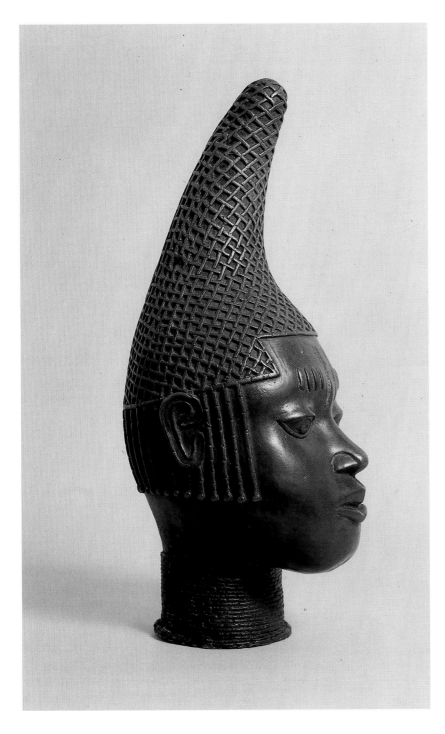

Non-Western 'sculpture', however, is very little concerned with reproducing features of the human anatomy accurately and, in particular, no expressive antithesis is drawn between flesh and bone, skin and skeleton. Little or no attempt is made to isolate and reproduce the characteristic physical features of individuals. Moreover, because verisimilitude is not a criteria for judging sculpture, one image might, in certain circumstances, substitute for another: different representations might be equally efficacious.

By contrast with the Western tradition and the emphasis on the depiction of personal characteristics, sculpture else-where has often used gesture, posture and stance to communicate a definite and precise meaning. Among the Kongo of Central Africa, for example, many images depict people with their hands and arms in particular positions, or with the body braced and the head turned. While such gestures and postures may, indeed, ex-press inner states (for example, grief or supplication), it is crucial to realise that they are conventions or signs which derive from society rather than from individuals. Like spoken languages these conventional forms pertain to society as a whole, and are learned and used by individuals only as members of society; they are not mainly or solely concerned to express a person's condition as an individual but as a member of a social group. To an outsider such postures may seem, as they did to the German Expressionists, to derive from some personal *Angst*, but to the indigenous user they express well-known conventional messages. In this sense such images are concerned not with depicting the indi-vidual nor with expressing some emotion or state exclusive or peculiar to a particular person.

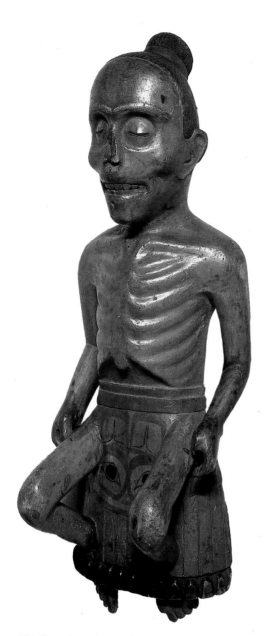

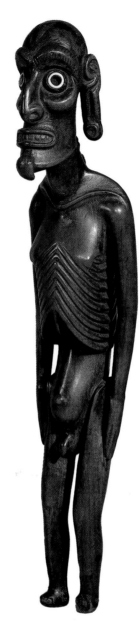

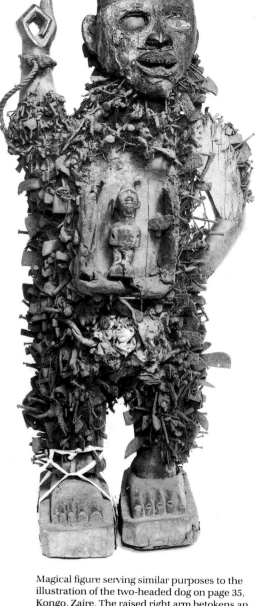

This figure from the Northwest Coast of North America appears to depict, with an unusual degree of realism, an emaciated man. An old label claims it actually depicted a 'medicine man' who died of starvation after breaking his legs in the woods. H. 56 cm.

Wood figure of an emaciated man, Easter Island. The exact significance of such skeletal figures is not known − whether, for example, they may be intended to honour deceased ancestors. Commemorative figures of this kind usually tend to emphasise the healthy body in the fullness of its powers. Sculpturally, and in terms of what they represent, the Easter Island wood figures are exceptional. H. 47 cm.

Magical figure serving similar purposes to the illustration of the two-headed dog on page 35, Kongo, Zaire. The raised right arm betokens an aggressive gesture indicating the power of the image to deflect evil influences. The posture reinforces the forceful but benevolent purpose of the image. H. 134.6 cm.

4
Masks and masquerades

We have already mentioned one form of sculpture which is distinguished from others by the circumstances in which it is used. This is the masquerade performance where the object — a mask — is usually donned by a human agent and where it moves, its style of movement contributing to its visual effect in ways which the static image cannot achieve in traditions that do not on the whole exploit the three-dimensional aspect of sculpted images.

It might seem that masks are a type of artefact with a predictable function. In one form or another they are known to most cultures, both Western and non-Western. As worn, masks hide, and thereby transform their wearer, regardless of the in-numerable possibilities of their external form and decoration.

Yet although all masks conceal the face when placed in front of it, there are considerable variations in the degree to which this is exploited in particular societies. For instance, it clearly makes a considerable difference to the understanding of masks and masking institutions, and to their local interpretation, whether or not the human agency in masquerade is generally known or not.

Secondly, the different contexts within which masks appear are innumerable: they may be used in mortuary, curative, magical, or agricultural and hunting rites; they are sometimes used in judicial process, in educational contexts, in initiation, and in theatrical realisations of mythic or historical events. Masquerades may frighten, instruct or entertain and amuse, and they may do any or all of these things in the same society, and even in the same performance. In Mexico, for instance, a standardised figure created from various images of the Devil turns up in many kinds of masquerade presentation often as a clown who tells rude jokes, makes obscene gestures, and generally undermines the seriousness of the surface theme being enacted by the other characters. The masking traditions of the Chokwe in Angola include a similar figure, a prankster who provides a counterpoint to the emotive qualities of the other masquerade characters. He interacts with the spectators, whereas other masks would be dangerous if approached in the same way.

There are also masks which although made in such a way that they may be worn are not in fact placed over the head. Amongst the Bangwa of Cameroon masks of the Night Society are conceived as possessing such power that they cannot be

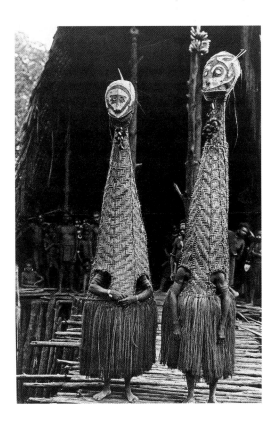

Complete mask and costume, the head of painted bark-cloth surmounting an elongated basketry neck and with a fibre skirt, probably Urama, Papuan Gulf. Such masks are used in the course of boys' initiation ceremonies, a familiar occasion for masking in many societies.

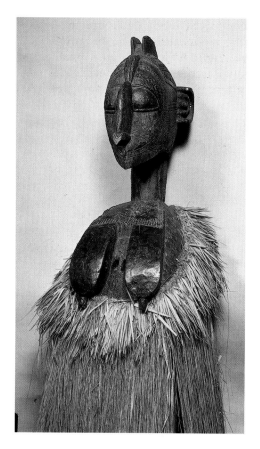

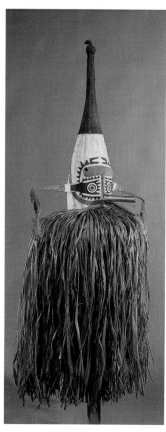

Above. This huge, heavy mask from the Baga of Guinea is carried on the maker's shoulders, the dancer looking through the eye holes set between the breasts. It is used in rituals connected with cultivation. H. 122 cm.

Above right. Mask from the Papuan Gulf. Such masks represent powers or spirits of the forest periodically summoned into villages for placatory feasts. They also serve in the initiation rituals, being made secretly and suddenly placed over the initiate's head. Many were destroyed after use. H. 152.4 cm.

placed over the head at all but are rather carried on the shoulder. In Mexico, amongst some Indian groups the physical location of the mask on the head may indicate the traditional or European origin of the character portrayed. Performers who appear to an accompaniment of Indian musical instruments will wear masks in such a manner as to cover the face, whilst those who perform with a band composed of European instruments may on occasion wear the mask on the side or even the back of the head leaving the face uncovered. Here distinctions are apparently being made between more traditional masks and

those introduced subsequent to the Conquest by Spain.

Masks are by no means always made of wood — wood, in fact, is only the most durable material used and, because of that, when masks are seen outside a specific masquerade performance they tend to be in wood. Cloth and metal masks, however, are also known, whilst assemblages made from an array of more fragile materials — basketry, leaves, feathers, bark, papier mâché, cane, fur, etc. — may be constructed for individual events. In these cases they may not be preserved, or indeed preservable, for use on subsequent occasions, particularly so if masking is only a periodic and occasional episode. In addition, although the mask may have similar significance and be taken to represent the same entity each time it is reconstructed, it may well have a different physical appearance on every occasion it appears. Such masks fall into the same category as those fetish figures discussed above (see p. 35) whose identity remains the same, although through use their external features and appearance may alter radically.

The mask, however rarely appears as a single artefact; the element of concealment is usually heightened by the addition of a costume of some kind which further disguises the masker. Again the materials of which this may be made are numerous — most frequently cloth, raffia or animal hide — and the amount of the body covered is equally varied. Whether the complete mask and costume are all-embracing and whether they cling to the wearer or not will determine the kind of disguise intended. Usually the human model of the masquerade is emphasised — the costume may suggest that male maskers are female, perhaps even that female maskers are male, but the fact that the masquerade is

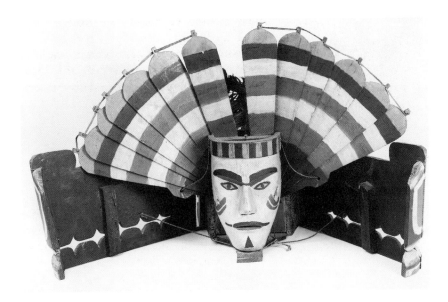

Masks which exploit the concealing and revealing aspects of masquerade by their actual construction are known from a number of cultures. In this example, from the Nootka of the Northwest Coast of North America, these are parodied by having an outer face (*below*) which opens to reveal another mask within (*above*). L. 49 cm.

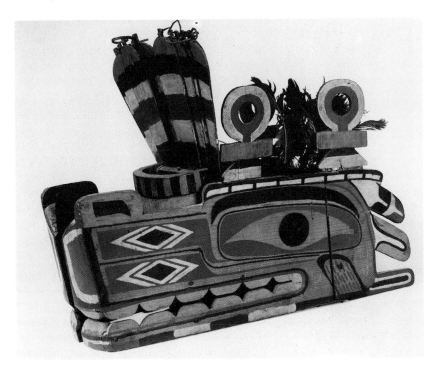

articulated in human terms is often evident. The most familiar exceptions are masquerades which play on animal forms, although oddities such as masks and costume that represent motor cars or paddle-steamers (examples being recorded from Malawi) are clearly more thorough in their attempt to conceal the human face and form behind the masquerade.

This question of concealment has received considerable attention in literature about masking. It is, for instance, argued that in such small-scale societies the performers in a masquerade are very likely to be known personally by those watching their performance. In the theatre when we watch an actor perform we know that he is only acting; but we usually know very little about his life off-stage that would otherwise impede any suspension of disbelief. The actor can be the character acted because we have no other expectations of him than those we are presented with in his performance. In any case acting is his profession; he is not – at least not by choice – also a farmer or a hunter or a blacksmith, occupations which would introduce another range of associations to confuse his theatrical role. In the societies under discussion individual maskers may have considerable fame and may indeed perform outside their own village or area. They too may be professionals whose skill is admired and who can expect payment for their participation in a particular festival or performance. Yet it is hard to think of any case where masqueraders are in full-time employment as such or derive their livelihood exclusively from it, other perhaps than as part of a modern national theatre group operating often in an international and commercial context. Otherwise the masker, whether or not specifically trained and recompensed for that role, is

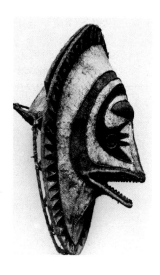

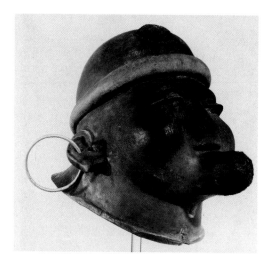

Above. Masks may be made of a variety of ephemeral materials and repaired (or replaced entirely) as the need arises. This example, from Papua New Guinea, consists of fibre made from the inner bark of a tree stretched over a cane framework and decorated with natural earth colours. H. 50.8 cm.

Above right. Masquerades may depict particular classes or types of people: in many cases this is done not only by the form of mask and costume but by the movement and acting of the masquerader and the accompanying music. This mask from the Makonde of East Africa depicts an Arab trader. H. 34 cm.

liable to have a whole network of economic, social, political, kin and domestic ties linking him to those before whom he performs.

Even in those societies where the human agency within masquerade is generally acknowledged the addition of a mask and the resultant anonymity accorded the performer may be an aid to more effective performance. The mask, like the exaggerated behaviour of persons in spirit possession, distances the performer from his everyday, known, existence in ways unnecessary in the more directly theatrical traditions of larger-scale societies.

Folk explanations, of course, are never pitched at this level. Most societies can usually furnish some, often widely accepted, view of the nature of masking. This may vary from person to person depending on whether they are 'in on the secret' or not. Male organisations, for example, may provide one form of explanation for the women and children before whom they perform masquerades but quite another for their own membership or for initiates. Often these will be couched in

mythological or quasi-historical terms. Yet whilst such accounts of origin serve to establish the pedigree of particular masks or masking institutions, they also implicitly or explicitly tackle questions concerning the mechanics of masquerade.

Firstly, it may be that local explanations of masquerade emphasise that the entity presented in performances is a genuine one, that what is seen actually is a spirit, an ancestor or some other extra-human being. In this case the knowledge of human agency is likely to be denied to all but those directly involved in the organisations sponsoring the performance. For everyone else, whatever their suspicions, the masquerade actually is what it is proclaimed to be. The mask and associated costume will usually cover the whole of the masker's body to heighten the illusion that what is seen is solid form. The effect in such cases may often be to invest the materials of which the masquerade costume is made and its visible properties with a particular significance.

Masks known under the general name of *makishi* are used in male circumcision rites in northern Angola, amongst groups who have migrated from there into Zambia, and in adjacent parts of Zaire. In the events which precede masquerade it is said that the *makishi* have been resurrected for the performances that are to follow. It has, therefore, often been thought that *makishi* represent in some way the community of ancestors. This, however, cannot be the case, for according to traditional conceptions ancestral spirits neither reside in graves nor are they visible. What are referred to are were-creatures and monsters ill-disposed to the human world, such as a man who returns from the dead as a beast of prey. Many of the names applied to individual masks make this clear, for they

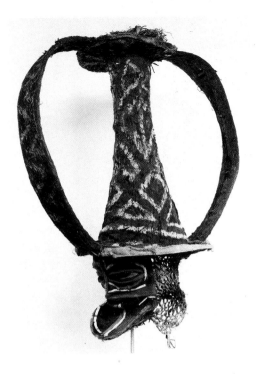

Mask constructed of bent twigs, covered with bark-cloth, the face of black wax with the detail added with coloured strips of paper, Chokwe, Angola. This and the next example are two of the most feared Chokwe masks. The materials of which they are made are impermanent and because of their inherent power destroyed after use. A more popular mask — for instance, that representing a young woman — may be made of wood and preserved for use on later occasions. H. 77.5 cm.

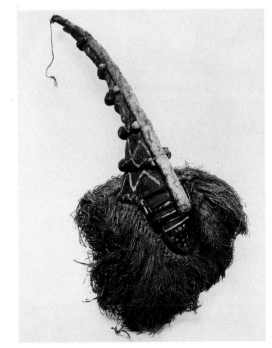

Mask constructed in a similar fashion to the previous example Chokwe, Angola. This form with the high conical projection is associated with the patron and overseer of a boy's initiation. Other objects associated with initiation and hunting amulets often contain references to the unusual form of this mask and the power with which it is imbued. L. 167.7 cm.

are names otherwise reserved to the familiars of sorcerers.

Other features surrounding the use of these particular masks are also consistent with these associations: those who have not themselves submitted to circumcision, for example, are said to contract serious illness if they touch a *makishi*, and indeed in some places it is considered dangerous even to walk on ground on which the masks have recently performed. Once the sequence of performances is completed, the masks and costumes are burnt thereby removing any evidence that masking is only disguise and also destroying materials which might be misused for sorcerous purposes.

The behaviour surrounding the public display of the mask, then, supports the view that in this, as in similar cases elsewhere, the mask is much more than a device to ensure the anonymity of the masker. Indeed, in significant ways *makishi* are not so much about concealment as about revelation. Their surface decoration in the colours red, white and black, which have particular symbolic associations, and their distorted form approximating human features, indicate the characteristics of the entity presented in masquerade. It is common in such cases for there to be no independent vocabulary to refer to the mask and the costume as separate artefacts. The mask is simply the 'head' of the masquerade and the costume its 'body'. The name of the masquerade is the name of the entity it presents. Often the extra-human beings or spirits which are the subject of the performance are regarded as visible in masquerade but not otherwise, thereby preserving the integrity of the personation effected in masquerade.

In Sierra Leone, in West Africa, the Sande Society of the Mende, a female organisa-

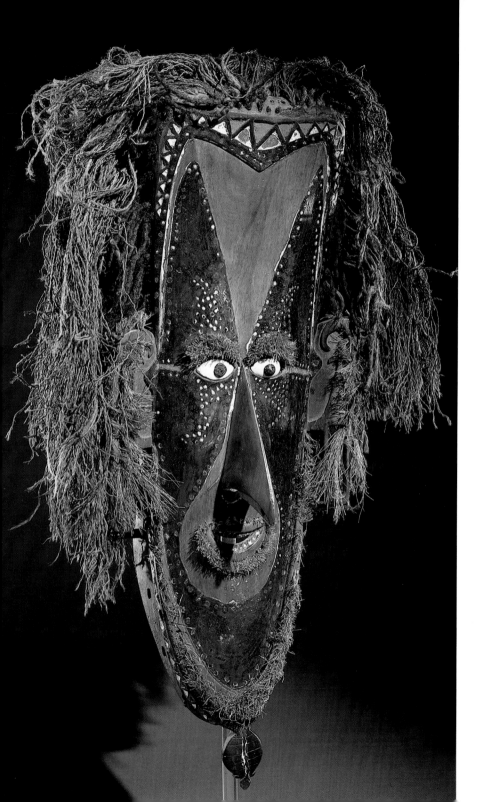

tion, performs masquerades in the course of its initiation rites. The masker wears a helmet mask carefully carved with features said to replicate ideals of feminine beauty. It is stained black, as is the costume worn with it, a mass of raffia which envelops the body of the wearer and completes its concealment. Here also there is no separate terminology to distinguish the various elements of the masquerade costume. The masquerade is the Sande spirit. What is visible is no longer a block of wood formed by the sculptor, and the stripped pared fibres of palm leaves; and the human occupant of the mask has become irrelevant by her invisibility. Indeed, her status as a person in everyday life is not improved by her performance as a masker, nor is it a primary consideration in her selection for the role. Masquerade makes visible spirits which are otherwise unseen in their more accustomed habitat in the forests beyond the dancing grounds of the Mende village. This act of making visible, of revealing, takes precedence from the Mende point of view over the act of concealment.

In such cases the artefacts used in the performance achieve extra dimensions in meaning by virtue of the fact that human agency is unadmitted and even firmly denied. The acknowledgement of the presence of the human masker, however, does not entirely remove the possibility of such broader significance attaching to the mask and costume. Between masquerades of the *makishi* and Sande types and more purely theatrical maskings are a series of performances in which the masks themselves carry an authority and power which is independent of the wearer and is belied by their more functional role of concealment. We have already mentioned the Night masks (see p. 49) of the Bangwa in Cameroon

which are regarded as possessing powers that render them too dangerous to wear over the head, the most vulnerable part of the body in terms of sensitivity to mystical dangers. Associated with the political and magical powers of the Society that owns and deploys them, these masks, though apparently once worn, have become emblematic.

This perhaps is a rather unusual example. More commonly the authority of the mask is established in various formulations and myths which may indicate that the costume now worn by ordinary mortals were formerly the preserve of gods or spirits. Amongst the Pueblo Indians of the south-western United States of America it is explained that divinities known as Kachinas once resided at the bottom of a lake. From here they would emerge periodically wearing masks and costumes and dance for the entertainment of the people. In due course the Kachinas taught men how to dance and to make masks and then disappeared, leaving some of their original masks to their human apprentices. Now the Kachinas return embodied in rain, and men dance their masks in associated calendrical rites and ceremonies.

Similarly for the Kalabari Ijo of the Niger Delta, Ekine Society masking and the plays associated with it were taught by Ekineba, a beautiful women abducted by the water spirits and carried off to their home beneath the creeks. Ekineba learnt all the dances of the spirits and when she returned to the land of men she was able to instruct the people there to perform plays. Although Ekineba was subsequently taken back by the water spirits, the masks and dances of the Ekine Society continue the tradition passed on by her. Kalabari masks are dedicated to individual water spirits in the sense that the mask or headpiece bears

its name and the dance steps and drum beat accompanying its performance are distinctive. Indeed, they are a more important guide to identity in some ways than a mask, since its form is often obscured when it is danced.

In both these cases — Kachinas and Ekine masking — the quasi-historical explanation of the origin of masking practices formerly carried out by spirits is associated with their occasional return during the masquerade. For the Pueblo Indians masks, as indeed other objects, are fed and conceived of as animate. When the masker dons the mask, he enters a space once occupied by spirits and to which they could again return. Indeed he takes ritual precautions appropriate to the occupation of sacred space: he makes a sacrifice and cleanses his head. There may be no particular test or sign to indicate the reoccupation of a mask by spirit, but the potential for such an event is clearly acknowledged.

The Kalabari Ijo, by contrast, have a well-recognised test of the actual presence of water spirits in their masquerades. Firstly, they travel to the distant creeks where the spirits reside and summon them to the forthcoming events. Spirits are said to 'walk with' the dancer enacting the performance whose style is associated with them. However literally this is meant, it is certainly the case that a successful masquerade for the Kalabari is reckoned as one in which the Ekine dancer comes to be possessed by the water spirit. The state of spirit possession is a clearly understood one whereby the masker is overwhelmed and enters a trance in which his gestures and movement no longer appear self-willed. He becomes in that condition the vehicle of water spirits, the mask concealing his everyday appearance, yet at the

Left. Mask from Saibai Island, Torres Straits, Papua New Guinea, worn in a ritual concerned with the fertility of crops. H. 55.9 cm.

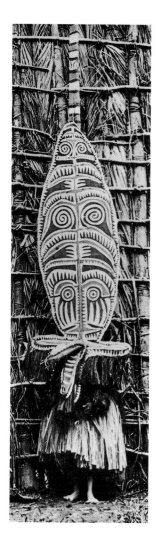

Masks of painted bark-cloth being displayed before a men's meeting house, Papuan Gulf. In the traditions of this region each mask of this type usually bears an individual name, many of which refer to mythological characters. In some places these are held to visit human society in the course of the periodic cycles of masquerade associated with them.

same time through the mythic history invested in it, creating the circumstances in which spirits may reveal themselves in masquerade.

There is certainly a divergence in the significance of the mask and costume as they appear here and in the personation achieved in *makishi* or Sande performances. In both types of event spirits are certainly made manifest. Yet there is a difference between a *makishi* which is summoned from the grave and appears as a masked figure, and a water spirit summoned from a remote creek which enters a man known to be already concealed behind the mask. In the first case it is the visible qualities of the mask which effect the manifestation, in the second the mask itself has been taken over by men and the reappearance of spirits is largely observable through the behaviour of the masker. For the Kalabari masks are little more than a helpful device for attracting spirits and are not regarded as powerful in themselves. There is no particular mystique or secrecy about their manufacture, and touching them is not as with *makishi*, a dangerous activity in itself. It clearly makes a difference, therefore, both to the character of the masquerade and to the evaluation of the artefacts used in it, whether or not human agency is a generally recognised feature.

It is also interesting to notice that in these two sets of masquerade, albeit for their different reasons, we are not really dealing with representations in a straightforward and obvious sense. In neither case are mask and costume constructed in the way they are to convey the nature of spirits visually. This is perhaps less clear in the first examples, but if we follow the logic of the situation described, it suggests that what is seen is in essence and substance

an actual spirit and is responded to as such. They are more than simply spirit-like, or substitutes for the real things. For their part, the use of Kachinas and Ekine masks have, according to tradition, been taken over from spirits. Although human artifice is entirely evident, masquerades were originally a mode of disguise even for the spirits from which they are derived. The link is not a direct visual representation of spirits but an indirect one. Again, the mask and costume are not simply a theatrical device to make up for the absence of spirits but rather a means to ensure their presence at particular events.

The best examples of masquerades in which visual likeness is valued and where there is an acknowledgement of the act of substitution (the masker for someone or something else, dead or alive, real or mythical) are perhaps those performances which are more directly theatrical. Here there is rarely any deliberate attempt made to conceal from the audience the mechanics of masking — even where a full costume is worn, it is not claimed that what is being enacted is other than impersonation. Children indeed, may even on occasion take part — as in one type of Mexican masquerade portraying dwarfs. Here concern for theatrical accuracy clearly takes precedence over the keeping secret of human agency. The Mexican tradition illustrates in some of its developments another feature of these more consciously theatrical performances. In these cases the presence of the mask is not in itself the subject of detailed explanation as in the examples above. It is the events and situations portrayed which are the focus of elaboration, not the fact of masking. The relationship between different masks that may perform together, their order and style of appearance, their behaviour, even per-

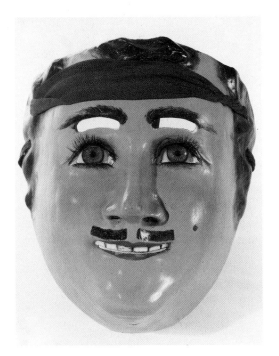

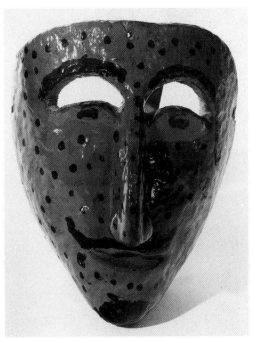

Right. Mask with a high gloss finish furnished with artificial eyelashes, glass eyes, a gold tooth and a red bandanna, Mexico. This realistic style is associated with carvers who otherwise specialise in producing religious images. Their work is not produced for use on any single occasion and does not seem to represent any particular kind of individual. It is, however, witness to the prolific masking traditions of Mexico. H. 16.5 cm.

Far right. Wood mask representing a Moor and used in the Dance of the Moors and Christians, Mexico. This example is painted red with black spots and may additionally refer to a smallpox victim. The Christians in such dances frequently appear without masks. H. 17.2 cm.

haps the words they may in some instances be required to speak follow a set pattern and form sometimes only a little less rigorous than a play with text and stage directions.

Mexican masking is particularly complex and vigorous, not simply a matter of a small group of masks or a single mask performing alone and only rather occasionally as in many parts of Africa or Oceania. Masked festivals punctuate the year, in remote villages as much as at important centres, the occasion often being a saint's day or perhaps a religious or national holiday. The nature of the performance is not necessarily correlated to the particular event, for masquerade is now a general means of public celebration. Its origins, however, go back to pre-Hispanic times, and some of its themes and characters still reflect more traditional Indian concerns:

they are associated, for instance, with rain-petitioning ceremonies in the appropriate season of the year. With the Conquest by the Spanish and the coming of Christianity many masked festivals were transformed. The image of the Devil, a Christian innovation clearly, and probably realised in some cases through the simple expedient of adding horns to masks of pre-Conquest origin has already been mentioned (see p. 49). Yet the details of the Conquest itself and of subsequent historical events are also the basis of masquerade.

The characters portrayed in the sequence of Conquest plays are numerous: Cortés himself, and the Aztec King Moctezuma, Malinche the Indian woman who acted as interpreter and is supposed to have become the mistress of Cortés, and a cast of Indian and Spanish soldiers. Another large-scale masquerade is the re-

construction of the course of the Battle of 5 May, the occasion in 1862 when the Mexican army defeated a French force at Puebla. As with the Conquest masquerades, masks and costume display motifs identifying with more or less accuracy the actual appearance of the participants. There is also within the Mexican corpus cycles of masked plays which tackle moral and religious questions, for instance, good and evil portrayed and contrasted as Christians and Moors.

In each of these cases the situation is rather different from that described above. The masquerade is not the subject of interpretation but the means of interpretation. In the Conquest plays Indian costumes are frequently more elaborate and dazzling than those of the Spanish protagonists. Pre-Conquest Mexico is presented as a Golden Age and the Conquest as a reversal of fortunes from which only the advent of the Christian era provided relief. Masquerade, in other words, presents a particular documentary view of history and in addition to its other functions has a didactic intent. The same can be said of the many cycles of masquerade elsewhere in the world which reconstruct the events of mythic history, prominent examples being the masking traditions of Sri Lanka, where up to 100 masked characters may appear in the course of a cycle of dance-dramas, and amongst the Dogon in Mali.

Masks whose functions are purely those of concealment are, in fact, rare – covers worn by boys or girls who are in the midst of the process of initiation into adulthood, or the veils familiar from the Islamic world. In parts of Eastern and Southern Africa, for example, initiates are usually kept in isolation during what can be a lengthy period of preparation for adult life. If they appear in

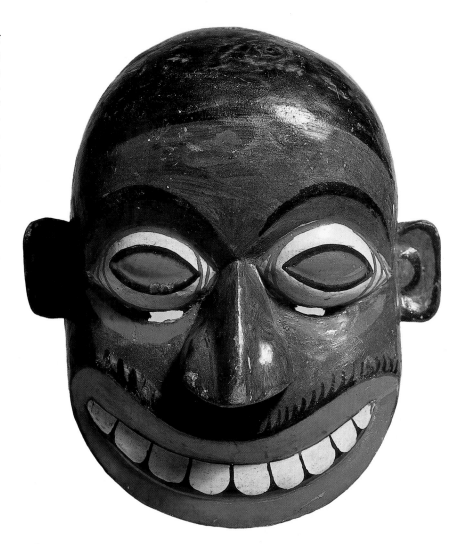

Above. Masked rituals are often concerned with giving a physical form to otherwise invisible or elusive entities. This mask from Sri Lanka is used in ceremonies to remove various types of afflictions, the mask and its activities helping the afflicted visualise their malaise. H. 26.7 cm.

Right. Kipsigis girl, Kenya, wearing a skin mask during the period of seclusion and social transformation which precedes her initiation into adulthood.

Far right. Mask, seen from above, in the form of a ray. Worn on the top of the head by young men during initiation, Bissagos Island, West Africa. L. 106 cm.

public, they often wear a costume of animal skin or vegetable fibre screening the face and frequently much of the body. The effect is to permit them to move around in public yet hide their actual physical appearance during the period of their transformation — a movable screen equivalent to the fencing that may surround the camp in which initiates are often isolated during this period.

It is also worth mentioning that such mask/screens are normally undifferentiated, and being virtually identical they classify their wearers, the initiates, as all the same. This is appropriate, for in their journey into adulthood they are no longer youths but are not yet adults either. All are in the same condition of social limbo, a point made visually by the identical appearance of the masks employed. Indeed, the more elaborated the mask becomes in sculptural or other ways, the less is its function describable simply in terms of concealing the identity or appearance of the wearer.

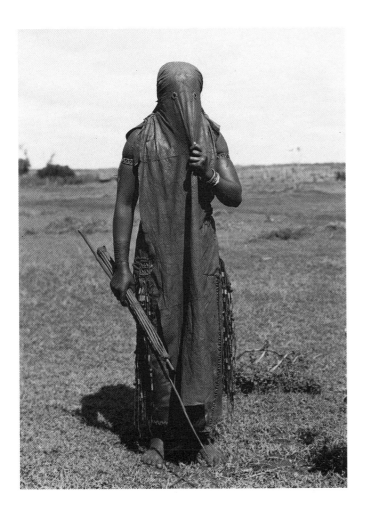

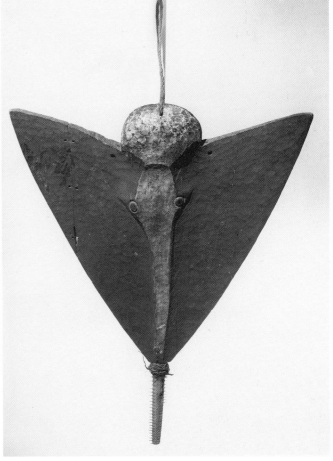

5
Form, volume and scale

As individual examples illustrated have shown, sculptural form alone provides no reliable guide to meaning where the viewer is otherwise untutored in any local cultural conventions deployed in visual imagery. In addition, apparently comparable forms may fulfil different functions from place to place, whilst diverse forms may serve equivalent purposes. Ideas about use, as about meaning, are liable to be misleading if guessed at solely on the basis of physical appearance. Despite this it remains possible to offer some general observations on the sculptural aspects of the traditions of the non-western world.

Two methods of achieving sculptural effects, particularly in wood-carving, may be broadly distinguished: one, the more familiar in a Western context, is by exploiting mass and volume; the other adopts what might be called a linear means, by emphasising silhouette, for example, or by carrying the figurative or other dominant elements in the surface decoration. Both are not infrequently intermingled in the same work to produce more complex effects. Furthermore, examples of both, and indeed their joint deployment on a single sculpture, are widespread, even to the point that they are sometimes found within the same culture. Yet there is a general contrast to be drawn between the

Right. This large figure from the Basongye of Zaire served to protect communities against mystical dangers. A patch of magically powerful material is fixed to the belly, and the horn and base probably contain more. The carving also made a noise: when carried on poles pushed through the gaps between the body and arms, the wood and metal bells which hang from it would sound to indicate its powerful presence. H. 105.4 cm.

Below. Much Maori carving was created to adorn buildings and has a strong emphasis on overall decoration and elaboration but little depth. L. 86.4 cm.

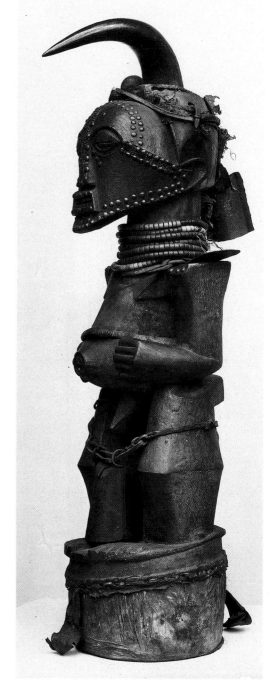

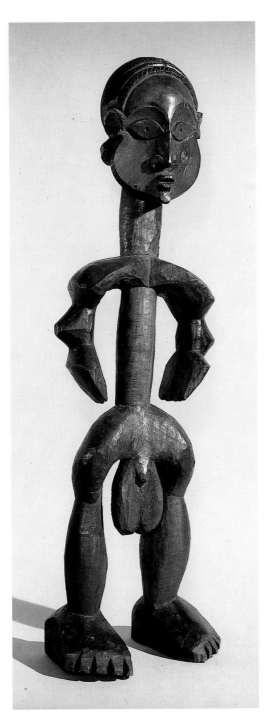

Figure from the Azande, southern Sudan. The use of such figures is not known, but at least some seem to have been made for sale to Europeans. This trade may have encouraged the development of a degree of stylisation in the representation of the human body unusual in this area. H. 80 cm.

extent to which each is characteristic of African and of Pacific sculpture. (In the Americas the distinction is not so apparent, except as a broad comparison of Northwest Coast forms with Latin American wood sculpture.)

The most immediate contrast, however, is between the three-dimensional character of much African sculpture and the much flatter nature of many Oceanic works. African sculpture nearly always gives a strong impression of masses filling space. When viewed from one position, it is able to suggest those volumes and forms hidden from the spectator; each angle of view serves to reveal different volumetric arrangements without diminishing the overall effect. Much Oceanic sculpture, on the other hand, depends for its effects more on surface decoration and outline than on interpenetrating or reinforcing masses.

The African emphasis on mass and volume is sometimes heightened by its use of the space enclosed by the form surrounding it. Thus rounded or angular shapes may be contrasted with hollowed-out sections, whilst the figure or mask may also intrude into surrounding space by the inclusion of, for instance, horn or plank-like projections. Because of this strongly three-dimensional, space-filling, space-occupying quality of much African sculpture, less importance tends to be attached to the work's silhouette or to its surface decoration. The application of surface decoration or coloured pigments to African figure sculpture is comparatively rare, except in the case of masks, which also make use of silhouette, seen clearly against the background as the masker moves. Sometimes the effect is increased by raising the masker on stilts, or he may appear on a mound or the roof of a house. Where such

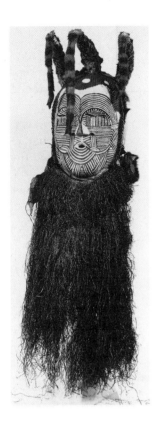

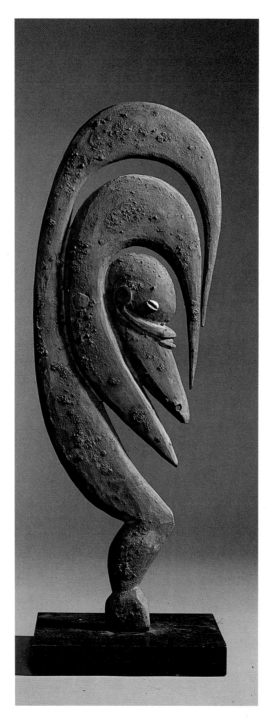

Above. The surface decoration of African masks, as in this example from the Batetela of Zaire, often creates a visual tension with the underlying sculptural form. This mask was collected shortly after it was painted, and so the vividness of the black and white contrast has been preserved to a degree unusual in museum specimens. H. 48.3 cm.

Right. This figure from the Karawari area, Papua New Guinea, is an almost flat image with great elaboration of form in the plane depicted here, and with almost no presence when viewed directly from the front or back. H. 86.3 cm.

surface decoration is used on figure sculpture, it generally serves to emphasise existing volumes and masses.

The case with much Pacific sculpture is very different. Here not only are many works virtually two-dimensional, but surface decoration is often used in ways unusual in African sculpture. Karawari figures from Papua New Guinea, for instance, when seen from the side, represent the human form reduced to a series of curves or hooks, which seem almost to dissolve away into the surrounding space. Seen from the front, the whole sculpture is almost invisible. Conversely, the form of many figures from men's ritual houses can be adequately viewed only from the front, and this frontality is often coupled with a subordination of sculptural form to surface decoration. In some cases the decoration may be carved into the work as in much late Maori carving, where the indigenous meanings of the work depend heavily on the combination of motifs and decorative features, rather than the overall distribution of masses.

Painting of Pacific sculpture is often more important than in Africa. The way the surface is painted and the colours used may actually serve to disguise or overwhelm the main sculptural masses. In the most striking cases, for example, in the Malanganns of New Ireland, there may be a total conflict at several levels between the sculptural form and the surface decoration. Malanganns are complex creations in which the sculptural form and space interpenetrate and combine to produce what is almost a turmoil of volumes and surfaces. Each surface is decorated in ways which serve to disguise or contradict its form. The result is that it is virtually impossible to perceive the overall form of the sculpture, and the eye is forced to shift from contrast-

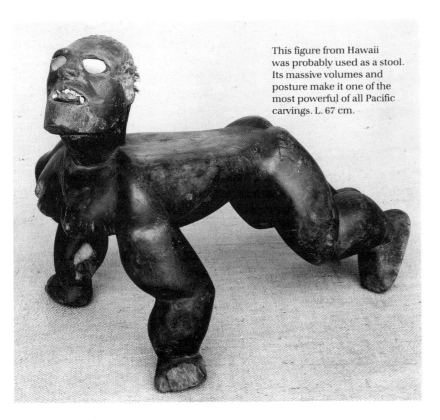

This figure from Hawaii was probably used as a stool. Its massive volumes and posture make it one of the most powerful of all Pacific carvings. L. 67 cm.

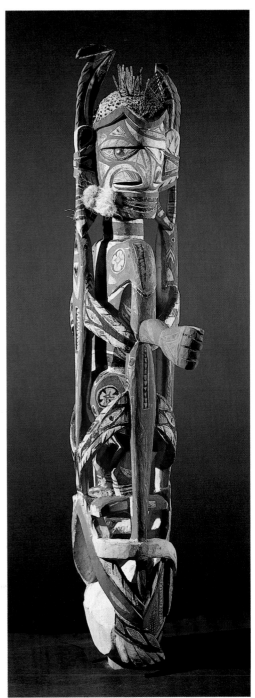

Right. The malanggans of New Ireland are formed to produce spatial complexity. In them surface decoration and carved elements standing clear of the core of the figure combine to create a multiplicity of volumes and planes. H. 142.2 cm.

ing surface to contrasting surface and kept perpetually in movement.

Silhouette is also important in the Pacific: in the case of dance crests or canoe ornaments the carver creates a two-dimensional pattern which the negative space serves only to emphasise the surrounding lines.

There are many exceptions to these generalisations that should not be minimised. It would be absurd to deny that there are important examples from the Pacific which in terms of volume and three-dimensionality are not directly comparable with much African work: a number of human figures from Hawaii are good examples. Equally, there are African works where the emphasis is on outline and not

volume. There are, for example, display pieces made by some Ibo groups in Nigeria which show a spatial complexity coupled with contrasting painted surfaces similar to the effects achieved by New Ireland Malanganns.

It has also been suggested that the differences between Oceania and African sculpture, in terms of flatness and outline against three-dimensionality, and surface decoration against volume, do not always hold good for African masks. Here there are many cases where the underlying form of the mask is disguised by the addition of pigments of contrasting colours, though not all masks are decorated in ways which contrast with their sculptural forms.

It has been emphasised that much of the sculpture in this book is not intended to be placed in a predetermined space but, by its presence, signals the existence of a particular space and situation around it; but sculpture, whether it occupies a fixed position in space, or is moved periodically from one place to another, or is seen mainly in a state of motion, is never perceived in isolation from its surroundings. How it appears in relation to these is often crucial in determining its effects.

Although difficult to judge from photographs alone, it is notable that most of the sculptures discussed reduce rather than increase the scale of the subject depicted. The large figures in stone of Easter Island and elements in the 'totem poles' of the peoples of the Northwest Coast of North America are the exceptions rather than the rule. A reduction in scale is a commoner feature of these traditions. In many cases there are good technical reasons for the production of small-scale works. Where the human body is the sole or predominant source of power people may not be willing or able to expend the energy needed to

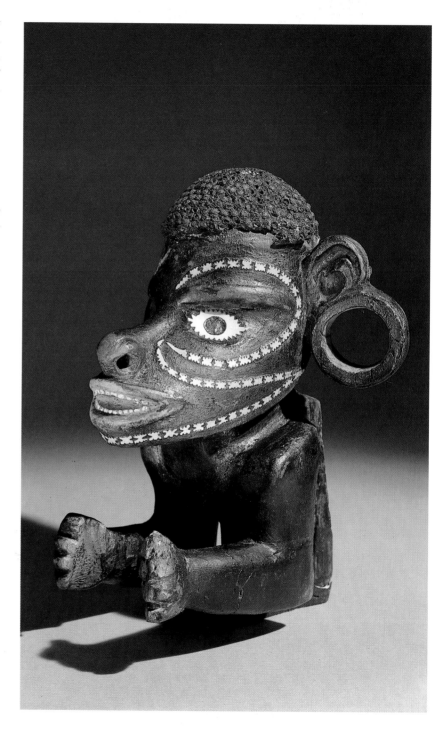

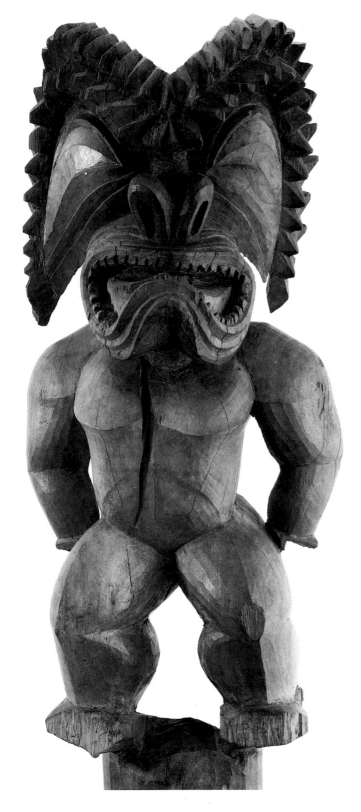

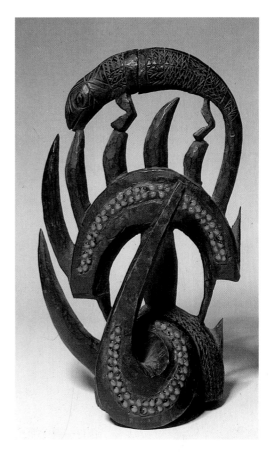

Above. A chameleon and cockscomb dance crest, Afo, northern Nigeria. The blackened wood contrasts with the red of the *abrus pecatorius* seeds glued to it, while sculptural emphasis is placed on silouette, particularly striking when the crest, worn on the top of the head, is viewed against the sky. H. 29.2 cm.

Left. Figures of Ku, the god of war, were placed in open-air temples in Hawaii. H. 122 cm.

Far left. Solomon Islands war canoes had attached to them, just above the water-line, a small carving to protect them and to exercise a malign influence on enemies. H. 36.8 cm.

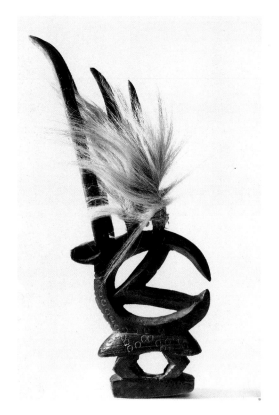

Dance crest, Bamana (Bambara), Mali. The Bamana have myths which link the antelope with the origins of agriculture, and highly stylised images of the antelope, worn on top of the head, are danced in rituals connected with growth and fertility. H. 43.8 cm.

create large images in wood or stone. (If, though, more easily worked and consequently ephemeral materials are used, large sculpture can be produced. The Baining of Papua New Guinea, for example, make huge masks of barkcloth fixed to a light framework of cane.) In those cultures where metal is used the sheer difficulty of working the metal and its scarcity may severely limit the size of what is created. Making large sculptures in terracotta is also difficult: large images may collapse under their own weight before firing and are difficult to fire. Large-scale sculpture, where it is made, is often connected with ideas about hierarchy, dominance and power.

The most extreme alteration of scale to be widely found is miniaturisation — the creation of objects so small that they can be conveniently held in the hand. Such sculptures are produced in many societies, though for a variety of different reasons and purposes. In some cases miniaturisation is clearly functional or technical: among the Akan tribes of Ghana and the Ivory Coast numerous brass-castings, 2 to 5 cm long, were produced to serve as weights for the gold-dust used in everyday commercial transactions. Large, and heavier, works would simply have been impractical.

The Inuit (Eskimo) of North America also made tiny sculptures which not only show a keen knowledge of many of the creatures which they hunted but also, apparently, a certain affection for them. Some of these carvings formed parts of tools, such as arrow straightners; others were used as toggles for garments or attached to hats or eye shades.

If sculpture is made for use on one particular occasion, this, too, may be a practical reason for its being rendered on a small scale. Where what is required does not have to last very long, it can also be made in ephemeral materials. In a number of societies very small unbaked clay sculptures are used to help instruct candidates being initiated into a higher rank of society or into some special association or brotherhood. The images are generally modelled by senior men (or very occasionally women) and are used to illustrate particular areas of wisdom in which the initiates are being instructed, or they serve as mnemonics for proverbs, jokes or myths. In such cases accuracy of depiction is rarely required or expected: all that is necessary is that the subject the sculpture represents can be recognised.

Among other groups, such as the Lega of

Central Africa, miniature sculpture made of more durable materials (ivory, wood and bone) is also used to help transmit and illustrate traditional lore. Each sculpture serves to call to mind proverbs or aphorisms which contain the essence of Lega wisdom. These images, however, are preserved by the initiates rather than necessarily discarded as objects in less durable materials might be. Thereafter they serve as continuing reminders of the moral lessons taught in a similar fashion to the small, ivory imitations of initiation masks worn elsewhere in the same general area.

Other uses include divination, where a miniature image may be manipulated, usually in combination with other items in order to clarify present circumstances or to reveal the future; or in bringing about a desired future, as, for instance, in the High Andes of Peru where small representations

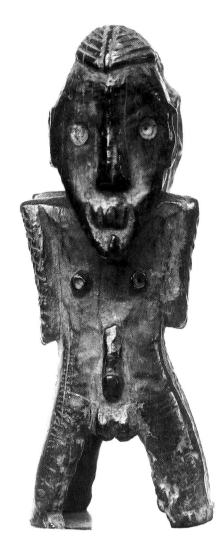

Above. One face of a Janus figure carved in bone, Lega, Zaire, used in the teaching of the knowledge and codes of conduct appropriate to different grades in the Bwami society, a major social and political force in life. H. 12.7 cm.

Left. Eskimo eye-shade of wood decorated with miniature representations in ivory of birds, whales and walruses, all animals hunted by the Eskimo. L.28 cm.

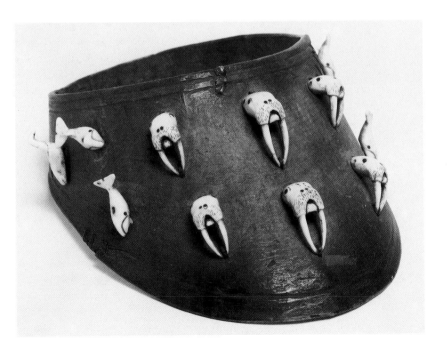

of desired goods (animals, cars, money, liquor) are made for an annual festival expressing the hope that these things will come into the possession of the user. More simply, of course, there are toys, the smallness of scale tailored to the user.

What, then, is implied in these various examples? It is interesting that many of the occasions in which miniature images are used have a broadly didactic intent. They are situations in which it is intended that the user grasp some emotional, moral or intellectual point, or, indeed, some characteristic depicted in the image and the force or power that it in turn may represent. After all, in reducing the scale of the entity depicted there is inevitably a concentration on those features considered most significant. Usually the image is also manipulated in some way, the scale permitting it to be handled, turned and inspected. The viewer is therefore brought into a very immediate relation to the image, and by extension to its broader import.

Moreover, there is a natural tendency to hold the image in such a position where it is viewed from above. The effect is not only to establish a scale in which the human body dominates the miniature image by its proximity, but also to emphasise the dominance by the superior viewing position usually adopted. This characteristic relationship of viewer to image is clearly exploitable as a corollary to all manner of wider moral or spiritual relationships in which the viewer may be placed. That miniature images may serve instructional, redemptive or divinatory purposes is one example of this.

The relationship of the human body to an image may also be exploited in other ways. In many parts of the world stools or head-rests are made with supports in the forms of humans or animals. In some cases

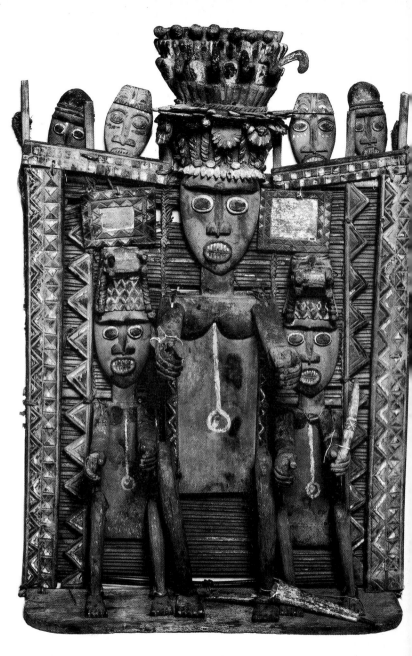

Above. Wooden screen, Ijo, southern Nigeria. These screens were formerly made to commemorate the deceased leaders of trading units. Their construction, by combining several separately carved parts, may owe something to European carpentry techniques. H. 129.5 cm.

Right. Brass plaque, Benin, Nigeria. The scene shows the Oba (king) returning from battle riding side-saddle in the manner exclusive to him. The smaller figures are court retainers, appropriately depicted in visually less dominant positions. H. 40 cm.

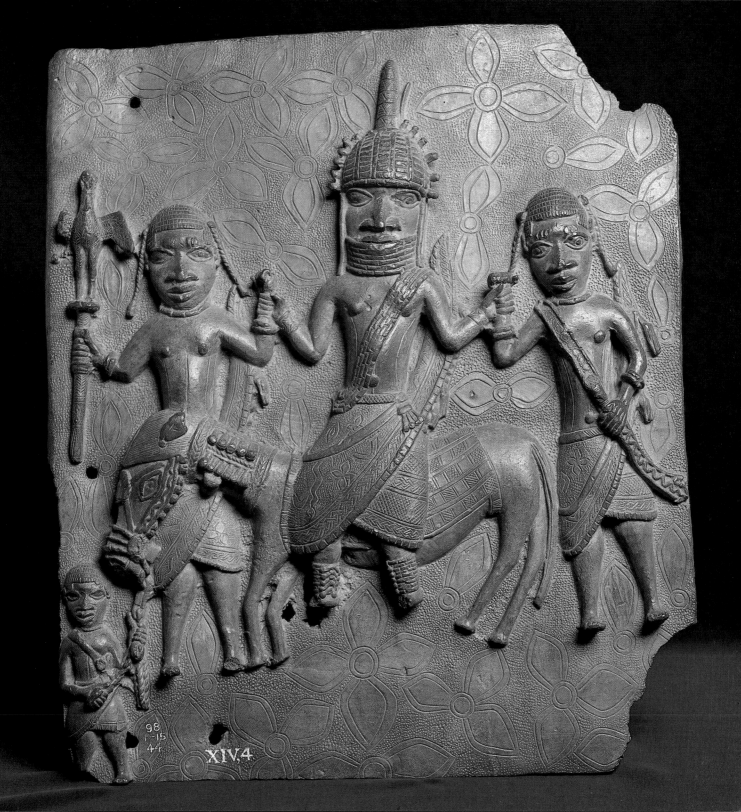

the image may be intended only to provoke amusement; in others it may serve to show the user's superior position, literally supported by, and bearing down upon, others. Similarly in the Marquesas Islands footrests, in human form, were used as stilt supports.

Finally, it should be noted that some sculptural constructions juxtapose several figures at different sizes. There may be an internal scale which can be used to convey the relative importance of the various beings or entities depicted. Chiefs or kings, for instance, may be portrayed on a larger format than servants or attendants. Political and hierarchical relationships within the human community are also expressed visually through the manipulation of scale. It is difficult to link form and scale with function and meaning in any predictable or regular way. Sculptural traditions notable for their imagination and vitality are not reducible to simple formulae. It is only, therefore, in rare cases such as these that we can ultimately glimpse the character of social relationships from the study of sculptural form alone.

Tableau from the Benin area of Nigeria, depicting a ruler and attendants.

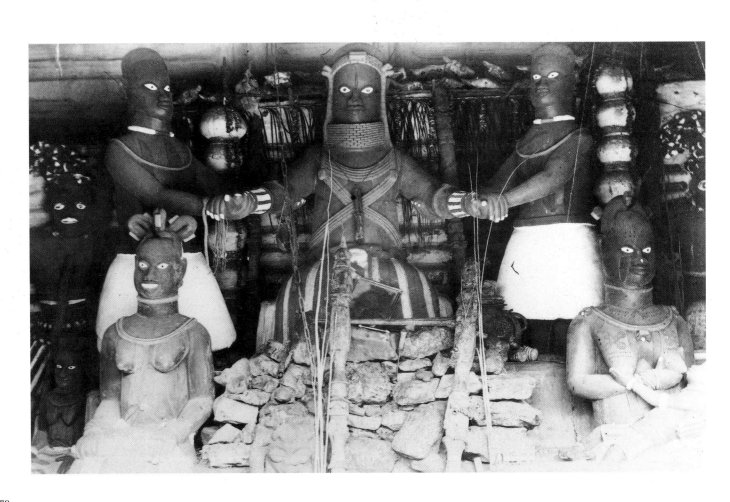

Wood stool, Luba, Zaire. One of approximately twenty examples in a style associated with the administrative centre of Buli. H. 52 cm.

Further reading

P. ALLISON, *African Stone Sculpture*, Lund Humphries, 1968

P. BEN AMOS *The Art of Benin*, Thames and Hudson, 1980

G. BANKES, *Moche Pottery from Peru*, British Museum Publications, 1980

T. BARROW, *The Art of Tahiti*, Thames and Hudson, 1979

R.T. COE, *Sacred Circles*, Arts Council, 1976

D.B. CORDRY, *Mexican Masks*, University of Texas Press, 1980

N.H.H. GRABURN (ed.), *Ethnic and Tourist Arts*, University of California Press, 1976

J. GUIART, *The Arts of the South Pacific*, Thames and Hudson, 1963

J.C.H. KING, *Portrait Masks from the Northwest Coast of North America*, Thames and Hudson, 1979

C. LEVI-STRAUSS, *The Ways of the Masks*, Jonathon Cape, 1983

S.M. MEAD and B. KERNOT (eds), *Art and Artists in Oceania*, The Dunmore Press, 1983

A. and M. STRATHERN, *Self-Decoration in Mount Hagen*, Duckworth, 1971

R.F. THOMPSON, *African Art in Motion*, University of California Press, 1974

Index

Inside back cover. Among the Bini and Yoruba of Nigeria, staffs made of sheet iron are used for various cult purposes. Their forms are closely related to the intractable nature of the material used. H. (max.) 58.4 cm.

Back cover. Such wooden figures were made to commemorate the kings of the Kuba people of Zaire. Different rulers were represented by virtually identical images, and there was no concern to delineate accurately the physical features of individuals. H. 55 cm.